WASHOE COUNTY LIBRARY

3 1235 02936 2311

P9-EDH-171

THE FRANK COLLECTION

A SHOWCASE OF THE WORLD'S FINEST FANTASTIC ART

Jane Frank

Howard Frank

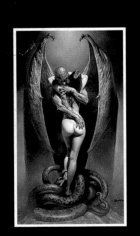

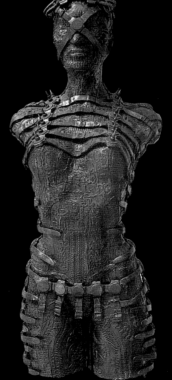

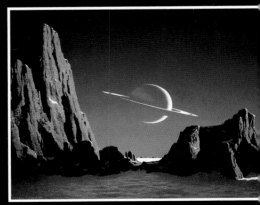

THE FRANK COLLECTION

A SHOWCASE OF THE WORLD'S FINEST FANTASTIC ART

JANE and HOWARD FRANK

FOREWORD BY JOHN C. BERKEY
AFTERWORD BY DON MAITZ
Photography by Gregory R. Staley

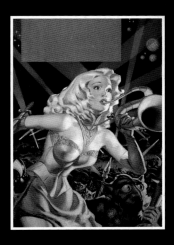

Illustrations on previous page, from left to right:
Boris Vallejo: *Demon Lover* (see page 83)
Virgil Finlay: *Mistress of Viridis* (see page 31)
H.R Giger: *Female Torso* (see page 73)
Chesley Bonestell: *Saturn Viewed From Titan* (see page 59)
Harold W. McCauley: *Mr Yellow Jacket* (see page 8)
J. Allen St. John: *Tarzan and His Mate* (see page 15)
Allen Anderson: *War Maid of Mars* (see page 37)

First published in Great Britain in 1999 by Paper Tiger
an imprint of Collins & Brown Limited
London House, Great Eastern Wharf
Parkgate Road, London SW11 4NQ
www.papertiger.co.uk

Copyright © Collins and Brown Limited 1999

Text copyright © Jane and Howard Frank 1999
Foreword copyright © John C. Berkey 1999
Afterword copyright © Don Maitz 1999

Illustrations copyright © individual artists or their estates (see picture captions); permission
is granted for reproduction in this volume

Thr right of Howard and Jane Frank to be identified as the Authors of this Work has been asserted by
them in accordance with the Copyright, Designs and Patents Act, 1988.

Distributed in the United States and Canada by Sterling Publishing Co,
387 Park Avenue South, New York, NY 10016, USA

All rights reserved. No part of this publication may be reproduced, stored in a retrieval system,
or transmitted in any form or by any means, electronic, mechanical, photocopying, recording or
otherwise, without the prior written permission of the copyright owner.

9 8 7 6 5 4 3 2 1

British Library Cataloguing-in-Publication Data:
A catalogue record for this book is available from the British Library.

ISBN 1 85585 7324
Commissioning Editor: Paul Barnett
Designer: Malcolm Couch

Reproduction by Global Colour, Malaysia
Printed and bound by Dai Nippon Printing Co. Ltd., Hong Kong

CONTENTS

FOREWORD

John C. Berkey

MOST DEFINITIONS describe a collector as a person who gathers together objects of value. The works of art gathered together in the Frank Collection are certainly objects of value: they are pieces which Jane and Howard Frank have in conjunction seen, understood and appreciated for their quality, and have chosen to make part of this unique 'family'. But taken as a whole they are more than that: the collection has become almost a work of art in its own right.

Let us look at this notion – the collection as artwork – a little more closely. As an artist, I know that not everyone sees exactly alike – each person brings to the act of viewing references derived from their own experiences. The Franks, however, seek to undergo this process together, and are able to see alike. This alone is a gift. Over the years the Franks have searched for and purchased many works with a discerning eye – looking always for those pieces that best represent each artist's imagination and skill. The knowledge the Franks require to select the artworks involves many personal characteristics – most notably an appreciation of the intent and skill of the artist along with the ability to see beyond the painted surface.

This past half-century has seen some truly remarkable work in the fantasy/science-fiction area. The films *2001* and *Star Wars*, the television series *Star Trek* and the films spawned by it – all these and others have brought forward a new audience not just for the movies and TV series but also for print. Jane and Howard Frank have been a constant part of this explosion of interest, as collectors and friends, patrons and at times advisers to the many artists whose works they own. Within the fantasy and science-fiction art areas, two subjects are the source of most pictures: works of pure fantasy based on old and new stories and the continuing view of tomorrow-as-it-might-be, connected to either fiction or fact. Both types of art rest comfortably side by side in the Franks' collection.

We are living through a period in illustration which may or may not be some kind of post-Golden Age. I do remember a time when painting was a matter of paint, brushes, a surface, an apple to keep one going and a radio, all done in a room with a door. Today it seems that the needs of many artists are often, right from the start, software, a keypad and a mouse... and an Apple. In their printed form many computer pieces are indeed very striking – much like well planned photographs. And the process would seem very clean: no solvents, no brushes to wash, no concerns about drying and no painting – no painting, the act, and no painting as the product at the end. Computer illustration may constitute the beginning of the end of what is possibly a unique artform and, if so, the Frank Collection, spanning as it does the better part of a century, may represent a crucial historical treasure.

Nothing that I can think of means more to an artist of any measure than someone taking the time to look at their work properly, ask questions and make the mental effort to see the effect the artist

intended. It is not the only reason that we work, but it is the most important. And artists listen. Maybe not all of the comments will be taken on board, but some at least of them will contribute to the artist's future work.

When I think of the number of pieces in the Frank Collection and the appreciation the Franks themselves have for each one, I cannot help but consider the positive effect these two people have had on those of us who labour in the hope that the choices we make in our art will elicit a response that goes beyond a mere reflection of what we, within our limitations, have been able to achieve. The Franks, through their ability to see, have aided many, many artists.

In this book, as well as leading you on an expertly guided tour through their magic cave of treasures, they seek to share that gift.

ACKNOWLEDGEMENTS

We would like to thank Malcolm Couch, Liz Dean, Cameron Brown and especially our tireless editor, Paul Barnett - all of Paper Tiger - who made this book possible. Our special thanks also to our indefatigable photographer, Greg Staley, who worked night and day (quite literally) on getting us the 'trannies' for the book. To all the people whose long-time association with the field and whose prodigious memories contributed to the telling of our tale, our thanks: Vincent Di Fate for his help in providing vital information; Bob Weinberg for his anecdotes and help in sleuthing out the 'art trail'; Helen de la Ree for her address book (and Gerry, wherever you are, we still blame you for getting us started on this obsession); Mel Korshak and Marty Greenberg for remembering a book fair in 1948; and 4E for his good humour and for giving our collection a boost just when we were ready. To David, Laura and Erica, our ever bemused but patient children, thanks for your understanding and for putting up with our collecting mania; to our parents, here and departed, in particular William Fox ('Foxy') Steinberg and Herman ('Hy') Frank, we hope you understand you are largely responsible for that mania. Thanks, too, to all the clients of Worlds of Wonder, and to other fans and collectors, who cheered us on while we were in the throes of writing. And, most especially, our thanks to all the wonderfully talented artists who have made our collection – and this book – possible.

Believe us, we couldn't have done it without any of you.

Jane and Howard Frank

INTRODUCTION

HOW IT STARTED:
A PERSONAL ACCOUNT

WHEN HOWARD was a small child his father would read him stories of space and science, of strange worlds and other universes. An enthusiastic reader and collector of science fiction, his father had a huge box of pulp magazines as well as shelves of books that were filled with fabulous stories and bore even more fabulous covers. So it's no surprise that Howard, too, grew up reading, loving and collecting science fiction and fantasy. Indeed, he learned to read only so that he could read science fiction! Caught smuggling one of these books into school, he was – as he can still clearly remember – chided by his teacher in fifth grade, Mrs Grossman: 'Howard, we don't read this sort of book in school.'[1]

During high school he made a great discovery: the used-book stores of lower Manhattan. Soon he was making weekly excursions in search of science-fiction and fantasy hardcover books, and these began to pile up at home. His favourite Christmas gift became the setting aside by his parents of the space for another bookcase. By the time he'd acquired three large bookcases he was, with the full self-importance of adolescence, referring to himself as a book collector.

We first met when Howard was a sophomore in college and Jane a senior in high school. Perhaps surprisingly, it was on a blind date. We immediately found that we shared a common interest: the weird and fantastic. It was a sure recipe for love at first (or at least second) sight. To prove it, Howard put together a master list of what he reckoned were the best books in the field to read – something akin to the 'masterpieces of literature' lists often distributed to college-bound high-school seniors – and lent Jane a boxful of them. This was some loan, since the box contained such treasures as the Arkham House edition of Robert E. Howard's *Skull-Face and Others* (1946), Isaac Asimov's original *Foundation* trilogy (1951–3), published by Gnome Press, and Clifford Simak's *City* (1952).

We married six years later. We papered the walls of our first apartment in Berkeley, California – where Howard was an assistant professor in the Department of Electrical Engineering and Computer Sciences – with pages torn from fantasy calendars and colourfully hokey science-fiction movie posters and lobby cards. *The Creature*

Avon Books cover (1950) for Jack Williamson's ***The Green Girl***.

Facing page
Harold W. McCauley: ***Mr. Yellow Jacket***, cover for *Other Worlds* (June/July 1951) illustrating a Ray Palmer story.
Oil on canvas board.
24in x 18in (61cm x 46cm).
Reproduced by arrangement with the Frank Collection.

One of our very favourite paintings, and one that never ceases to make us smile.

[1] To be fair, she was probably making the mistake of judging the book by its cover. It was the Avon edition of Jack Williamson's *The Green Girl* (1950), and the illustration — by an unknown artist — on the front of Howard's sin-drenched book showed a fantastic monster holding a beautiful, semi-nude green girl.

Gabriel H. Mayorga: **Juice**,
cover for *Super Science* (May 1940)
illustrating the lead story by
L. Sprague de Camp.
Tempera.
30in x 22in (76cm x 56cm).
*Reproduced by arrangement with the
Frank Collection.*

from the Black Lagoon (1954) shared the walls with *The First Men
in the Moon* (1964) and... The books piled up and the bookshelves
filled up, and wall space quickly became a rare asset as poster art
competed with bookcases for this precious commodity.

We liked giving parties. Our guests, mostly colleagues from the
University of California, often expressed interest and amusement at
our curious taste in art. We think that it was probably at Berkeley
that we first encountered the since oft-repeated question: 'How do
you sleep at night?'

We moved from California to New York in 1969 when Howard
started up his first telecommunications company. Together we
discovered science-fiction and *Star Trek* conventions. These became
a great way for us to spend a weekend. While Howard would spend
hours in the dealer rooms hunting books and magazines, Jane was
discovering convention art shows. At the same time, and without
any grand notions or expectations, Jane began to track down artists
through the simple means of writing to publishers. An early success
was finding Frank Utpatel, the illustrator of Arkham House's H.P.
Lovecraft book *Collected Poems* (1963). We were thrilled to be
corresponding with a Real Artist, and even more thrilled to discover
that the originals of six of the interior pictures for that book were

available for sale. After intense deliberation, we purchased two full-page black-and-white illustrations; our budget would not allow us to acquire all six!

The inflow of books and magazines continued. Buying pulps in bulk – sometimes hundreds at a time – became a habit. A complete collection of *Amazing Stories* was the first big coup. Then came full sets of *Planet Stories* and *Fantastic Adventures*. Boxes of *Astounding Stories* and *Weird Tales* followed. Lacking enough bookshelves, we moved the couch to the centre of the room, then shifted the rest of the furniture, and then, still lacking space, moved to a larger house.[2]

Both of us were by now caught up in the absorbing search for affordable images ($35 for a piece of art was a big deal for us). To take just a single example, in 1973 we purchased a small but exciting painting of a ghoulish creature by an unknown amateur artist. That artist, Michael Whelan, has gone on to become the most-honoured science-fiction illustrator in the world, and when he visited us last year we had fun showing him this early purchase of ours. It has been continuously displayed on our walls for twenty-five years, even though we've moved four times and many other paintings have had to be put temporarily into closets or drawers (the ignoble 'flat files') waiting for their turn to be let back once again 'into the open'.

A major victory came during a visit to the late Gerry de la Ree, a legendary collector of books and art who, along with his wife Helen, had assembled a vast trove including hundreds of drawings by such artists as Virgil Finlay and Hannes Bok. During that visit we saw a wonderful 1944 *Thrilling Wonder Stories* cover painting by Earle K. Bergey sitting on the floor, leaning against a bookcase. Jane remarked how much she liked it and, on a whim, Gerry sold it to her for $75. It was the most we had ever paid for a painting – and it was our first colour cover.

Wow! What a buy! Totally unexpected! If we hadn't been fanatic art collectors before then, this experience would surely have converted us.

HAUNTING THE CONVENTION ART SHOWS

After this we discovered how much we loved full-colour cover art.

At a convention in New Jersey in the early 1970s Howard spotted a painting from across the room that looked like a Hannes Bok. He dashed over to it, and indeed it was a Bok – a *Marvel Science Fiction* cover from 1951. The bid sheet listed an instant sale price. Howard, refusing to let 'his' painting alone for even a moment, shouted and waved to Jane, who obediently took the bid sheet from him and made the purchase right there and then. We loved the picture at the time and we still love it now.[3]

[2] This pattern has continued. Right now we've called a halt to moving, but to make up for it we're in the midst of a building project that will add seven rooms to our house to hold the collection.
[3] And it even came with a freebie; printed on the back of the painting was the name of its previous owner, Jack Gaughan, a noted science-fiction illustrator in his own right.

Virgil Finlay: ***Palos of the Dog Star Pack***, cover for *Famous Fantastic Mysteries* (October 1941) illustrating a J.U. Giesy story.
Oils.
20in x 14in (51cm x 36cm).
Reproduced by kind permission of Lail Finlay Hernandez.

Hannes Bok: ***The Fifth Power***, unpublished, thought to be created in preparation for the last in Bok's *Four Powers* series of lithographs, c.1940s.
Tempera.
30in x 22in (76cm x 56cm).
Reproduced by arrangement with Forrest J. Ackerman.

Robert Gibson-Jones: ***Armageddon***, cover for *Amazing Stories* (May 1948). Watercolours. 19in x 13½in (48cm x 34cm). *Reproduced by arrangement with the Frank Collection.*

Facing page Hannes Bok: ***Loss of Gravity***, cover for *Marvel* (November 1951). Watercolours. 16in x 11in (41cm x 28cm). *Reproduced by arrangement with Forrest J. Ackerman.*

Even though we actually owned a copy of the *Marvel* magazine this painting illustrates, we had the painting hanging upside-down for fifteen years before a visitor pointed out our mistake! It was almost like getting a new painting when we hung it the way Bok had intended.

With that purchase we learned how much fun finding art could be. Howard's heart still beats faster when he remembers the thrill of spotting that Bok painting.

And so the hunt was on. We began to scour east-coast convention art shows, and rooted out dozens of pieces. Our annual calendar looked something like this:

In February it was Boskone, in Boston. March had Lunacon, hosted by the Lunarians, in New York. Come April we headed for Balticon, in Baltimore. Disclave, in Washington DC, was in May. After Howard and a friend made the first trip to a World Science Fiction Convention (Worldcon), in 1979 (Miami), the Labor Day weekend in September was annually reserved for the Worldcon. In November there was Philcon, in Philadelphia. In the Fall, wherever the World Fantasy Convention happened to be held we'd be there. And then there were the twice-yearly *Star Trek* conventions in New York.

We would usually hit a convention on the Saturday morning and go directly to the art exhibit. We had a typical routine. We'd split up, each surveying the show on our own and each making a list of the paintings we liked. That done, we'd compare our picks – and, remarkably, we'd find that on average 90 per cent of our entries were the same. Then we'd prioritize our preferences and place written bids; by Sunday afternoon we might have put in bids for 15–20 paintings. Usually we'd walk out of the show owning ten or more new paintings. After a while it was the case that, wherever we arrived, the word would soon go out: 'The Franks are here.'

Many artists attend convention art shows; it is their way of meeting fans and, perhaps more importantly, book and magazine art editors. That's how we first came to meet some of the greats of the field – Kelly Freas, Richard Powers and Michael Whelan, to name just three. We found ourselves drawn to them. Here were friendly, interesting people, happy to talk about themselves and their work.

We became art groupies, eager to hang around the art displays for hours, engaging artists like James Gurney, Don Maitz, Barclay Shaw, James Warhola and Dean Morrissey in endlessly fascinating (for us at least) conversations about their techniques, their careers and their incredible imaginations. On top of liking them as people, we were usually in awe of their ability to conceive their spectacular images and translate what they imagined into such wonderful creatures, situations and scenes. Beyond these conversations, there were slide shows and panel discussions, and soon we became friends with folks like Jill Bauman, Ron Walotsky, John Berkey and Darrell K. Sweet, and were invited to their homes and studios. Conventions became an opportunity not only to meet and speak with the authors, publishers, editors and art directors of books we enjoyed but also to say hello to all the artist friends we had made over the years.

We also discovered two new facts. First, you could call artists and buy their paintings outside of art shows. Second, the words 'Not For Sale' attached to a painting didn't mean the painting was not for sale.

The year 1985 was a big one for us. Howard sold his interests in his second company. We moved from our house in the New York

Edward Valigursky: **Slaves of the Klau**, cover for the novel (one half of an Ace Double, paperback) by Jack Vance, 1957.
Acrylics.
20in x 15in (51cm x 38cm).
Reproduced by kind permission of the artist.

Ron Walotsky: **Cortez on Jupiter**, cover for the novel (Tor, paperback) by Ernest Hogan, 1990.
Acrylics.
28in x 20in (71cm x 51cm).
Reproduced by kind permission of the artist.

We've known Ron for many years – it was a case of 'instant simpatico' – but, even though we'd often shared dinner and spent countless hours talking, Ron kept silent about the large body of his abstract, non-sf paintings. A visit to his house revealed closets full of huge symbolic works in wild colours and patterns. Cortez combines Ron's more traditional science-fiction illustration with his wilder gallery art. Cortez, the artist, is surely Ron, the artist, in disguise. The spaceship emblem being painted by Cortez also exists as a 5ft x 5ft (1.5m x 1.5m) oil painting, most likely still hanging on Ron's wall.

suburbs to bigger premises, a four-storey city townhouse, and suddenly had a huge number of blank walls and spaces crying out to be covered and filled. We more or less officially gave up the effort to find art in commercial galleries and general public exhibitions. We took to playing a 'name the artist' game in bookstores – pick a book, name the artist without looking at the copyright page, and then tally up at the end of the session to see who had got the most right. Then, of course, we would call the artists to try to buy the paintings we liked best.

The 1986 Worldcon, held in Atlanta, was a particularly good convention for us. We bought a dozen paintings on Sunday morning, packed all of them up on Sunday afternoon, checked them as fragile air baggage on Sunday evening and were hanging them on our walls by late Sunday night.

THERE'S NO SPACE TOO LARGE

December 12 and 13, 1987, were the most important days of the decade so far as our collecting was concerned. Those were the two days on which Guernseys Auction House, in New York, held an event called 'The World of Forrest J. Ackerman at Auction'. Hundreds of paintings and thousands of books, magazines, movie posters, stills, ephemera and artefacts related to science fiction were put on the auction block. Collectors from all over the world assembled in New York for what still remains in memory as the most spectacular auction in the science-fiction and fantasy world. The Franks were there, you bet – and we came armed with a letter of credit from our bank.

There were dozens and dozens of paintings by such greats as Frank Frazetta, Chesley Bonestell, Boris Vallejo, the Brothers Hildebrandt, Kelly Freas, Frank R. Paul, Virgil Finlay, Hannes Bok and Harold W. McCauley. Everywhere we looked there would be another great piece to drool over. Hot and heavy bidding for Frazetta's most famous *Conan* painting reached $45,000 before the painting was withdrawn for failing to meet its reserve price! We acquired an exquisite 1956 Finlay *Other Worlds* cover. Four Boris paintings, including his famous *Demon Lover,* joined our hoard, as did a 1939 Frank R. Paul *Fantastic Adventures* back cover. But the most spectacular of our acquisitions was Margaret Brundage's first *Weird Tales* cover – the September 1932 *Altar of Malek Taos*.

This auction marked a turning point in our collecting. We walked away from the sale with eighteen paintings – a wonderful hoard of classical and contemporary gems – and a reputation that we were serious contenders for 'The Best'.

It took us six years to fully saturate our next house, four floors and 4500 square feet of space. We developed the habit of referring to exhibition spaces in our home as if they were independently conceived public areas – rooms and even spaces were given names of their own.

By 1991 every wall, every space, every bathroom, every closet door and every closet was covered or filled. We invested in special gizmos so that the paintings would not be jarred when the cabinets

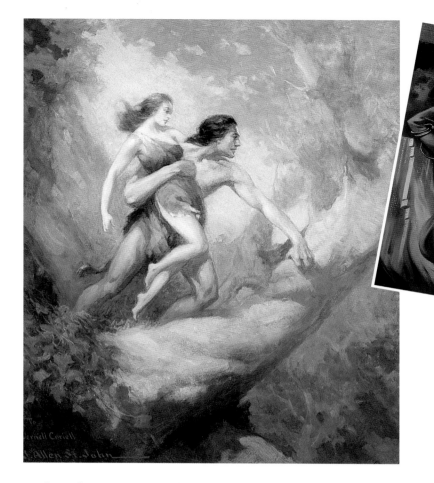

Above
Howard W. McCauley: **The Cosmic Bunglers**, cover for *Imaginative Tales* (January 1956) illustrating the lead story by Geoff St Reynard.
Oils.
22½in x 16in (57cm x 41cm).
Reproduced by arrangement with the Frank Collection.

Left
J. Allen St John: **Tarzan and His Mate**, private commission, 1947.
Oils on canvas.
22½in x 19in (57cm x 48cm).
Reproduced by arrangement with the Frank Collection.

or closet doors were opened and closed. We stacked boxes of books in closets meant for guests' coats, and started to use chairs as easels. Our children, one by one growing and leaving the nest, no longer had bedrooms to come home to: their rooms were now art-gallery sitting rooms. (No, they never had nightmares when they were growing up, although the passion for collecting has to date afflicted only one of them.)

Our home at that time was 'urban'; within walking distance of our house were over thirty restaurants, dozens of shops, movie theatres and bookstores. For one brief month during those years we found ourselves looking at nearby rental apartments where we could hang and store art, under the pretence of using it to accommodate visiting children and friends. At the end of that month we came to our senses and began a serious search for a larger house – one with the architecture and atmosphere that would complement the collection.

We found that house, and it is the one that you will be touring in this book.

We could use pretentious phrases like 'profound satisfaction' and 'aesthetic succour', but the overriding truth is that building this collection has been – and remains – incredible *fun*. Sharing these works of art, and seeing the pleasure and entertainment they bring to others, has always been our delight. We hope you enjoy the artworks displayed in these pages as much as we enjoy bringing them to you.

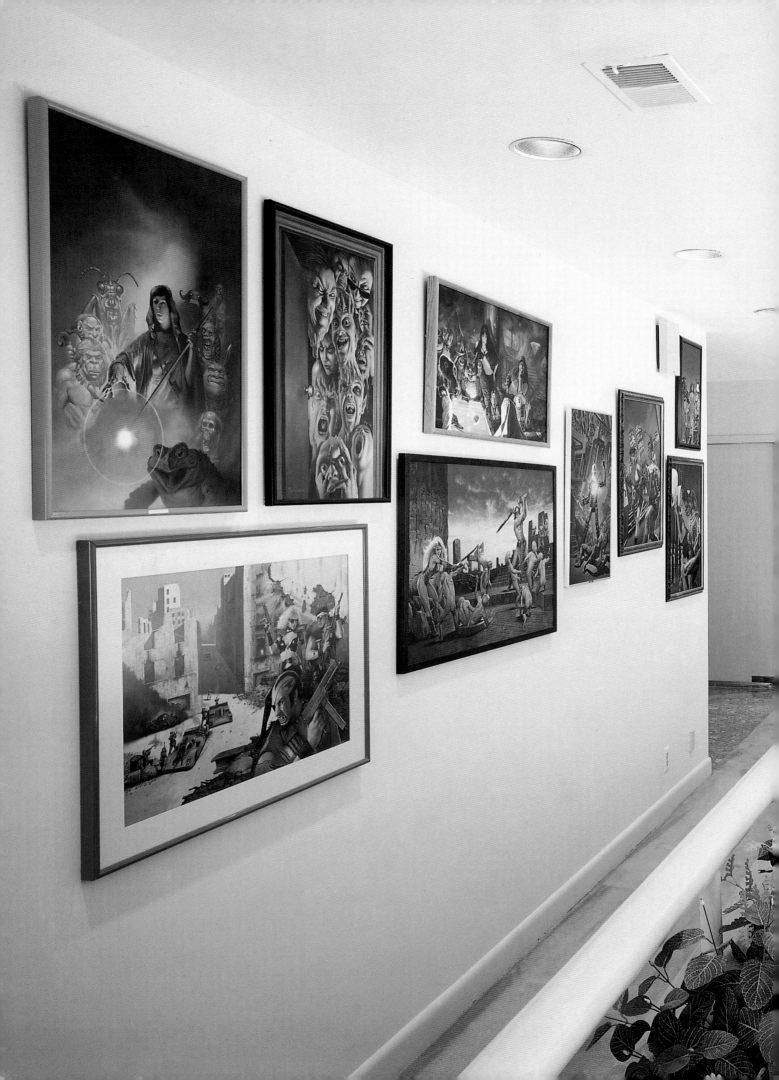

MAIN LEVEL

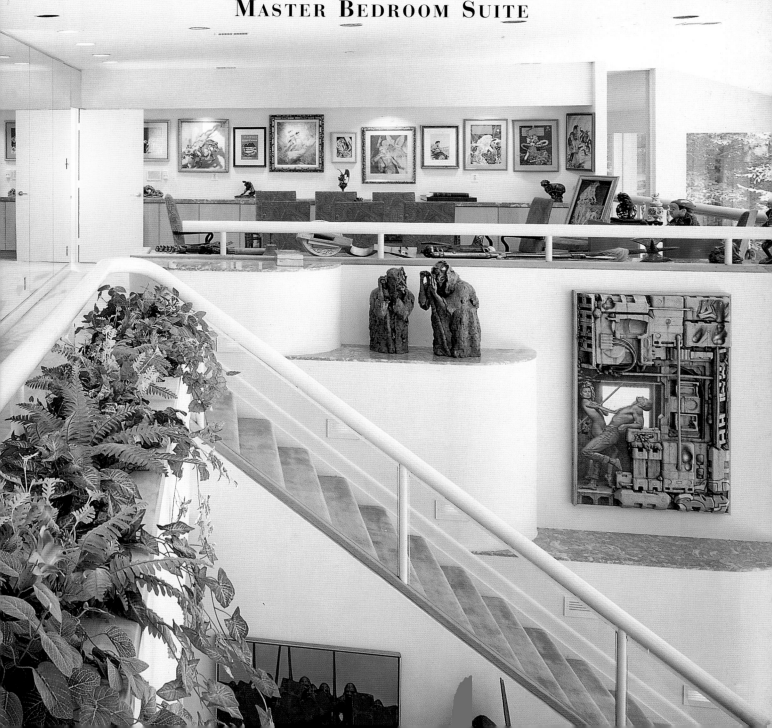

CHAPTER 1

ENTRYWAY AND
GRAND STAIRCASE

NOT EVERYONE understands or appreciates science-fiction and fantasy illustration. To most people, illustrations are just bright little pictures on book covers, and many otherwise sophisticated art lovers never realize that, behind each cover, there may be a full-size, dazzling work of art. Our entryway is often the first experience that people have ever had with our special passion.

We choose art for our entryway with some Don'ts and some Dos in mind. *Don't* shock, scare, revolt, offend, titillate, tax or bewilder. *Do* amaze, astound, surprise, amuse, charm and cheer. *Most importantly*: Choose some of the most dramatic paintings to greet the visitors.

On entering, you are welcomed by, on the right-hand wall, Jim Burns's covers for an edition of Ray Bradbury's *The Illustrated Man* (1951) and for David Wingrove's *The Middle Kingdom* (1989; the first volume in the *Chung Kuo* series, see page 22) and Steve Youll's cover for Ian McDonald's *Speaking in Tongues* (1992). On the left-hand side of the hallway, directly facing these and with a nineteenth-century commode and mirror separating them, are Richard Bober's cover for Stephen Goldin's *The Storyteller and the Jann* (1988) and Donato's cover for Barbara Hambly's *Mother of Winter* (1997).

These paintings, each exquisitely detailed, stand at the height of

Facing page
Steve Youll: ***Speaking in Tongues***, cover for the novel (Bantam Spectra, paperback) by Ian McDonald, 1992. Oils.
24in x 17in (61cm x 43cm).
Reproduced by kind permission of the artist.

Below
Jim Burns: ***The Illustrated Man***, cover for the novel (Bantam, paperback) by Ray Bradbury, 1990. Acrylics on illustration board.
16in x 26½in (41cm x 67cm).
Reproduced by kind permission of the artist.

This was one in a series of commissioned covers for Bantam Books' Bradbury series; it also went on the 1990 Society of Illustrators (NY) national tour.

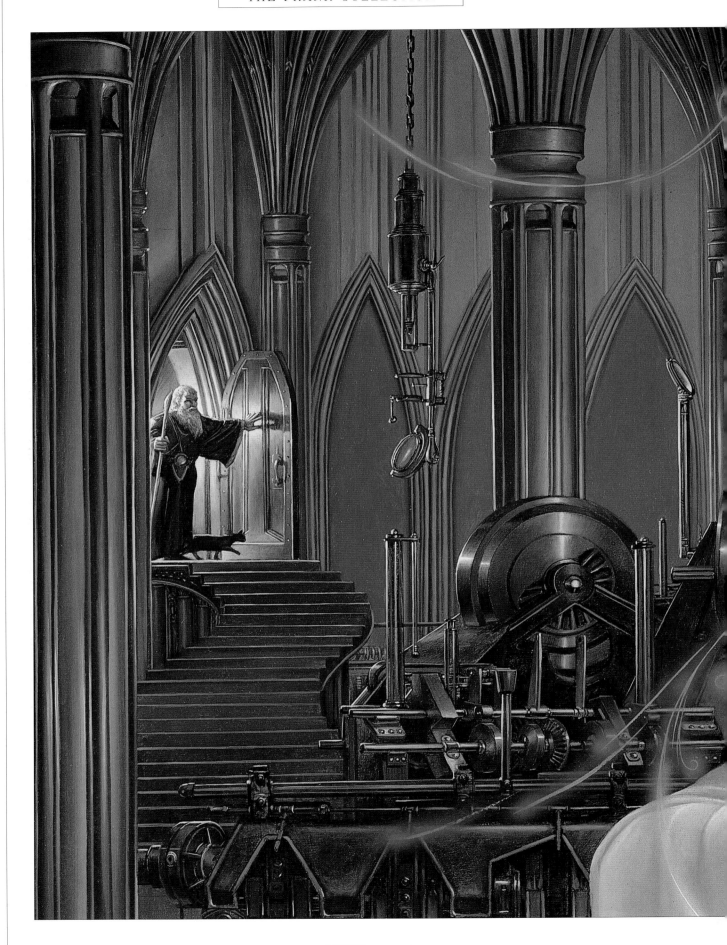

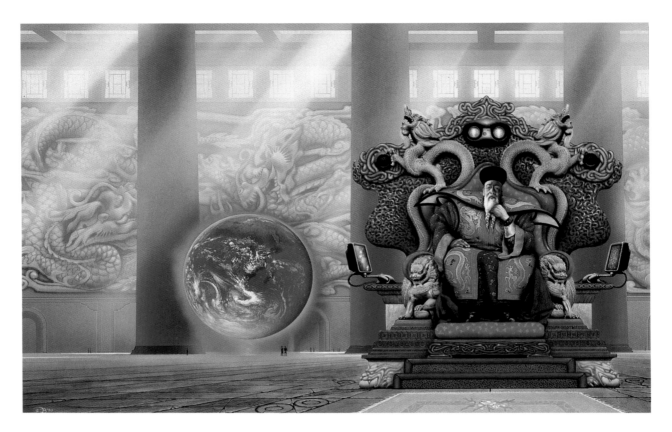

Jim Burns: ***Chung Kuo***:
The Middle Kingdom,
cover for Book I (Dell, paperback)
in the series by David Wingrove, 1990.
Acrylics.
20in x 30in (51cm x 76cm).
*Reproduced by kind permission of
the artist.*

When Jim told us that **Chung Kuo**
was available, he referred us to a small
reproduction on its paperback edition.
While this was interesting, its details
were hardly visible. Fortunately, the
painting was hanging in an exhibit at
the Society of Illustrators in New York,
which Howard visited while on a
business trip. He was captivated by
the painting, returning again and again
to look at it. We bought it the very night
he returned to Washington.

Preceding pages
Donato: ***Mother of Winter***,
cover for the novel (Ballantine,
paperback) by Barbara Hambly, 1997.
Oils.
22in x 34in (56cm x 86cm).
*Reproduced by kind permission of
the artist.*

The first time Jane saw this painting
she fell in love with it, never thinking
that others might have the same
response. But, surprisingly, everyone
who sees it is entranced by the image,
even though the character portrayed is
clearly a startling one.

representational art in our collection. The humans, aliens, 'context'
and composition seem alive and real. Youll's painting of McDonald's
hero might easily be mistaken for a photographic portrait, but then
so might that of the creature facing him! The throne, leather, jade
and Asian ruler of *Chung Kuo: The Middle Kingdom* could all be
taken from photographs in the pages of a weekly news magazine, but
so could the huge suspended planet Earth and the massive walls
covered with dragon murals in the background. Bober's jann (djinn)
comes directly from the legend, but the jann's cave is lined with
luscious velvet, fabrics, stone and gems – altogether, a delightfully
seductive joy to the senses. Donato's unearthly but compelling
woman is a fitting companion to Burns's mysterious tattooed man.

We first saw this latter painting, Burns's *The Illustrated Man*, at
the 1990 World Science Fiction Convention in The Hague. It was in
a dimly lit corner but its power was still evident. When Jim offered
it to us we grabbed it. We believe this is one of the greatest fantasy
illustrations ever painted. The image is brilliant; its implementation
is perfect. The tattoos of the Illustrated Man, marvellous images on
their own, are integrated into his flesh and muscles so that every
pore and every muscle fibre combines to bring them to life.
Moreover, Jim has framed this image in such a way that what is not
shown is also intriguing and exciting. On the one hand it'd be great
if someday Jim painted the remainder of the man, but really it's
better this way, because viewers can complete the picture using
their own imaginations.

The visual intensity of the entryway paintings is calculated to
stop visitors in their tracks. And to make them think, if only for a

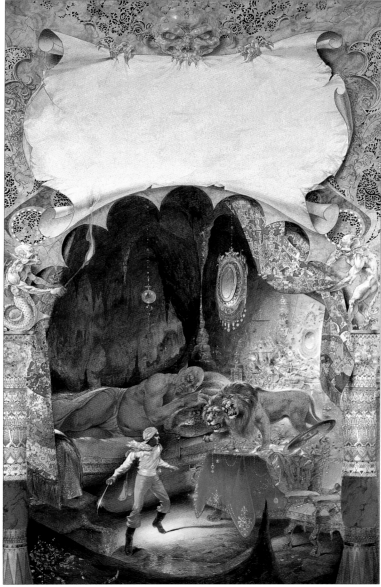

Richard Bober: ***The Storyteller and the Jann***, cover illustration for the novel (Bantam, paperback) by Stephen Goldin, Volume II in the Parsina Saga, 1988.
Oils on board.
45in x 34½in (114cm x 88cm).
Reproduced by kind permission of the artist.

Richard Bober is a remarkable artist – a throwback to earlier times when an artist might labour tirelessly in a garret to perfect his art. Because his work is so detailed and finely wrought, he is able to produce only a few paintings a year. We are usually very decisive in picking art, sometimes making a selection in only a few minutes, but it took months of thought before we acquired this painting, torn as we were between several amazing Bober images that were on offer to us.

short while, about the power of such figurative art. Art appreciation for many of our visitors is shaped by today's notion of 'high art'. The more outrageous, the more experimental, even the more 'accidental' or 'fresh' the style of execution, medium or technique, the more creative, and therefore the more desirable, this art may appear to mainstream critics. In this Fine Art world, style of execution and technique are presumed to be related to the presence or absence of artistic originality, whence all good things creative flow. Our collection makes clear that we don't conform to that mind-set.

In our view, originality in execution is immaterial, with cause (originality) and effect (conventional or unconventional execution) being unrelated. What counts is how well and how clearly the message comes through. On seeing these paintings, any two visitors' attitudes towards our favourite artform can never be the same. These paintings are our way of 'cleansing the viewer's palate' and flushing away stereotypes and preconceptions. Who could not view

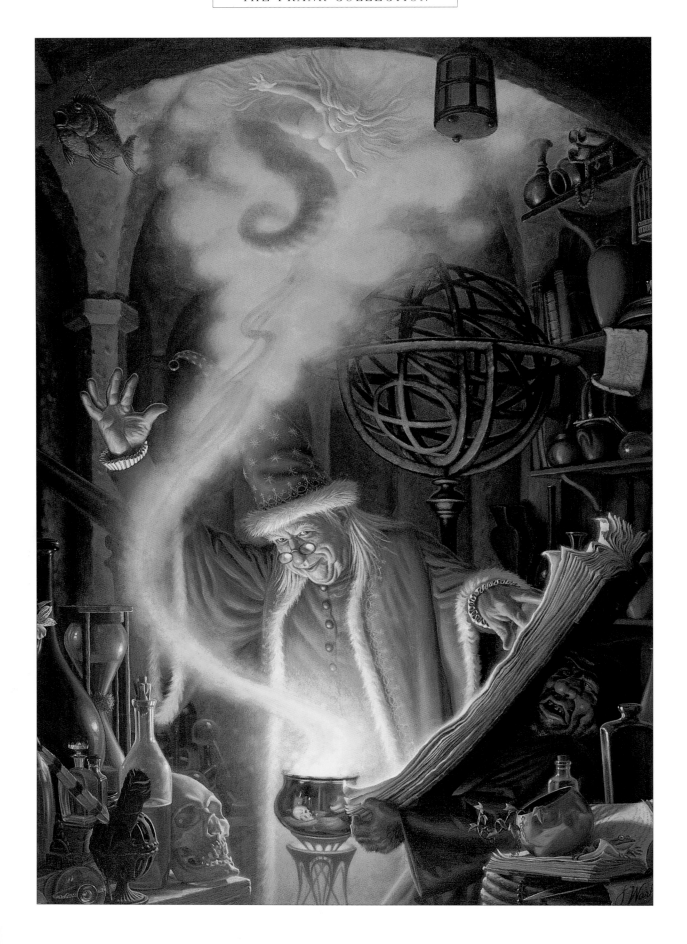

James Warhola's wonderful *Portrait of an Alchemist* – the kindly wizard, his gnarly servant, and the issue of one well cast spell – and not feel refreshed by the humour, the skill and the imagination of the artist?

We think that Warhola, the nephew of Andy Warhol, is the most imaginative artist in the family. Buying this painting was nearly a year-long affair for us. We first saw it on display at an art show. Jim was unwilling to sell it because he said it was only partially complete (it looked finished to us). Months later it was again on display, and by now the smoke, flying fish and many other elements had been added.

But the entryway paintings are only the first part of our 'one–two' punch. The second part is the house itself. Looking at the frontage, you might assume that the house was a modest (but large) one-storey California-ranch-style dwelling. The unsuspecting visitor doesn't realize that the house is built on the side of a hill, and that its rear wall is a multistorey suspension of glass and brick overlooking a massive forest. Eight steps into the house and this surprise is revealed. And the sudden knowledge that you have entered not on the first (ground) floor of the house but the second, and are facing a forty-foot expanse of window overlooking a terrace and woods, can come as quite a shock! To your right the Grand Staircase descends to the twenty-foot-ceilinged Living Room area, lined by sculpture and art.

It usually takes a moment for it all to sink in. Art and sculpture are everywhere – covering the walls, along the staircase, sitting in chairs, poised on marble ledges, lurking in corners, creeping along the floor . . .

A Mexican wooden Day of the Dead sculpture, an articulated skeleton, six feet tall, wearing a glow-in-the-dark baseball cap, sits in an entryway chair. The skeleton is a permanent guest – his cap and other apparel change with the season. During the winter a muffler and a ski hat come out (although in the winter of 1998/9 he acquired an appealing 1940s fox wrap in place of the muffler); during the summer he sports sunglasses.

Guarding the front door is our dog *Spot*, a charming mix of Norwegian elk hound and alligator. Spot is cross-eyed, mangy and ugly (just what we had ordered) but we love him. Created by Jeff Coleman, he is a loyal companion who never needs feeding or to be taken to the vet, and he rarely barks or bites strangers – or moves around very much at all, in fact. *Spot*'s presence complements the drama of the paintings at the entrance to the collection, saying, in effect: *'Not only is this stuff great, it's also great fun!'*

Four routes take our visitors from the entryway into various sections of the house. To the right, travelling along an open hallway overlooking the Living Room, is the Balcony Gallery, then the Reverence Room and the Master Bedroom Suite, entered by first passing through a special place reserved for a special piece of functional art: a chaise longue. To the left as you enter the house is a doorway into the Kitchen. A few steps beyond this doorway is another opening, again to the left, this one leading into a Classic Art hallway, at the end of which is the Dining Room and its Wall of Fame, and, beyond that, to Jane's Office Suite; a 'back' stairwell, lined with

Facing page
James Warhola:
Portrait of an Alchemist.
personal work, 1990.
Oils on canvas.
48in x 30in (122cm x 76cm).
Reproduced by kind permission of the artist.

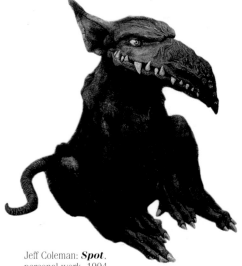

Jeff Coleman: **Spot**.
personal work, 1994.
Resin and mixed media, including a lot of mangy fur.
About 30in x 28in x 18in (76cm x 71cm x 46cm).
including tail and ears.
Reproduced by kind permission of the artist.

When our six-year-old grandson first saw 'our dog Spot' he insisted that it was not really a dog. Times change. Recently he visited with a friend and proudly showed his friend 'my grandparents' dog Spot'!

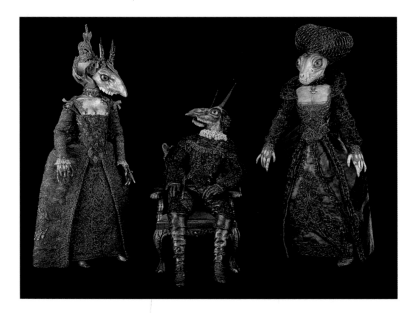

Adnan Karabay: ***Gorgonnia Boria, Pyra and Mandrake***,
trio of elegantly costumed dolls, personal work, 1995–96.
Mixed media, including fabric, paint and small mammalian skulls.
Figures stand 24in (61cm) high.
Reproduced by kind permission of the artist's agent, Neil Zuckerman, CFM Gallery, New York.

Barclay Shaw: ***Subway Love***,
personal work subsequently used as cover art for the novel *Kaleidoscope* (Del Rey, paperback, 1990) by Harry Turtledove, 1988.
Styrofoam, wood, canvas, and paint.
62in x 40in (158cm x 102cm)
Reproduced by kind permission of the artist.

classic examples of science-fiction and fantasy art, takes you from the Pulp Hall to the Lower Level.

The main Grand Staircase leads, as we've seen, down to the Living Room. Marble ledges line one side of this staircase. On the top ledge are three splendid 'dolls'. One male and two female, these dolls – *Gorgonnia Boria, Pyra and Mandrake* – the work of Adnan Karabay, are dressed gorgeously for a ball in sparkling jewelled gowns. The male gazes lovingly at one of his female companions.

A second ledge holds two witch-like ceramic clay and porcelain figures, each 40in (1m) tall, exchanging a gold coin (not shown). Then, suspended over a third ledge, is a large mixed-media construction by Barclay Shaw titled *Subway Love*. This piece, combining canvas, styrofoam and wood, is part painting and part sculpture. We've known Barclay and bought his paintings for many years. However, he was surprised when we asked him at Boskone 1989 if he would sell this work; he had put it up 'for display only'. He told us: 'I never thought about it. It's an experiment that I never thought anyone would want.' Even before it had won a First Place Award in the Professional division at that sf convention, we had convinced him that it was indeed wanted – by us. We had been saving a wonderful wall space in our 'city' house for the perfect piece. This was it. When we moved, there was another equally perfect space, here alongside the Grand Stairway.

The other side of the Grand Stairway, enclosed by only a protective rail, overlooks the Living Room and the Sword & Sorcery Guest Room, with dozens of artworks. But even before you reach the foot of the stairs your eyes will be transfixed by the sight of the captivating sculptures in the Living Room promenade area – works by H.R. Giger and Gary Persello as well as Lisa Snellings's astounding and thrilling fantasy carnival (see page 75 for more on these).

By the time you reach the bottom of the Grand Staircase you'll have become, we hope, a permanent believer in the brilliance of this special artform, although these first steps into the lower levels provide only a hint of what is yet to come.

CHAPTER 2

THE KITCHEN

WE CHOOSE paintings because of their aesthetic appeal to us. We try never to buy a painting just because of the particular artist who painted it or the particular book it happened to illustrate. We place the pictures in locations according to how often we want to see them, how often we want others to see them, and how well they look in a particular environment. Sometimes paintings move several times around the house before they find their final, 'comfortable' resting place.

Since we are in the Kitchen more often than in any other room, excepting our offices, we choose for this room art that will never be tiring to our eyes. Sometimes that will be, for a period of time, paintings all in a single genre, and on occasion that genre will appeal to one of us more than to the other. Howard loves space art, while Jane's tastes run more to furry critters. But lately we have agreed that a kitchen is an ideally suited place for the display of paintings featuring high-tech and futuristic scenes. As a compromise to Jane, our kitchen-counter surfaces are still reserved for furry critters and their friends – while leaving some room available for Robby the Robot.

We have taken a great deal of time over laying out the present scheme, and it's always subject to change. One wall lends itself particularly well to the display of large horizontal works, so that

Paul Lehr: *City*, cover for the novel (Collier, paperback) by Clifford D. Simak, 1991.
Oils and acrylics.
23in x 14in (58cm x 36cm).
Reproduced by kind permission of Paula Lehr.

This cover was part of a major display by Paul at the 1992 Lunacon Convention in Stamford, Connecticut, where he was Artist Guest of Honour. Before that we had only one minor piece by him, and had never seen any others. This exhibit opened our eyes to his great talent, and we acquired two paintings there (the other was *Island City in Green*, page 30); we have since bought five more.

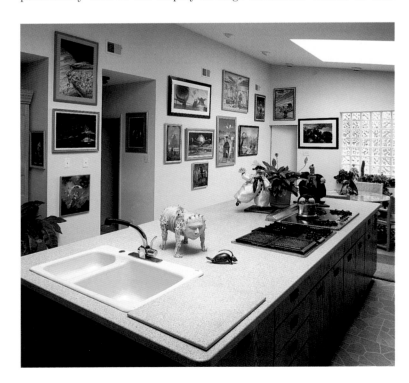

The Kitchen.

Above
Jim Burns: ***The Reality Dysfunction***,
cover for the novel (Pan–Macmillan,
hardback and paperback) by Peter F.
Hamilton, first in a trilogy. 1995.
Acrylics.
20in x 49in (51cm x 124cm).
Reproduced by kind permission of the artist.

Jim always loves to show off his best
pieces at World SF Conventions, and he
went over the top at the one called
Intersection held in Glasgow in 1995
(where he won his second Hugo). As usual,
he marked his major works NFS (not for
sale), partly because he's not anxious to
sell them and partly because he never
thinks anyone would actually buy them
for the price he should reasonably set.
However, he'd forgotten that we're used
to overcoming both obstacles when it
comes to buying Burns paintings.

Right
John Berkey: ***Space Settlement***,
AMP Corporation commission. 1988.
Casein and acrylics.
16in x 28in (41cm x 71cm).
Reproduced by kind permission of the artist.

each time we acquire a new work of suitable magnitude there's a
decision to be made: 'How well will the new one look here?' The
large Chesley Bonestell painting *Lunar Landscape* (see page 61),
currently in the Reverence Room, once occupied the space now
taken by Jim Burns's cover for Peter F. Hamilton's *The Reality
Dysfunction*; before the Bonestell arrived for its sojourn here the
space held a similarly proportioned Richard Powers painting, *Mars
Cityscape* (see page 66), which is now in our master bedroom.

But it's rare that only one painting must be moved each time a
new artwork is added to the collection. For example, the paintings
'bumped' by our two most recent acquisitions for this space (by Paul
and Steve Youll) were given a new lease of life through being moved
to Howard's business office at the University of Maryland. But not
all paintings have been so lucky... which is the main reason we're
adding seven rooms to the house.

In the case of space paintings and sciencefictional spacescapes,
one might be tempted to think an arrangement by colour scheme
would be an efficient solution to the challenge of displaying the art
in the Kitchen. Midnight-blue vistas of outer space and starry skies,

Paul Lehr: ***Island City in Green***,
personal work, 1988.
Oils and acrylics.
24in x 21in (61cm x 53cm).
Reproduced by kind permission of Paula Lehr.

This painting was reproduced on the
cover of Algis Budrys' sf magazine
Tomorrow in 1994 and on the cover of
the anthology *L. Ron Hubbard's Writers
of the Future Vol. XIV* (1998).

silver rocket ships, green Martians – these are the sorts of colours
that come to mind. Regrettably that kind of thinking has never
worked for us. Richard Hescox's purple-hued cover illustration for
Allen L. Wold's *The Lair of the Cyclops* (1992) may complement
John Berkey's orange-red *Space Settlement* on a formal colour
wheel, but visually they are quite different and so the two occupy
opposing, rather than adjacent, walls. We hope that they will remain
distant neighbours, but of course there can be no guarantees!

CHAPTER 3

THE DINING ROOM AND ITS WALL OF FAME

THE DINING ROOM is the heart and soul of our collection. The sole available wall space here is a long, rather narrow horizontal strip, so the only paintings we and our guests see when dining are the ones hung here. For that reason we regard it as our Wall of Fame, and the pictures we choose for it are among the oldest and rarest we own.

Like many other art collectors, we love to tell stories about our paintings, and our guests often need an introduction to the collection as a whole. So, over dinner, our Wall of Fame provides an ideal background for pleasurable discussion and the sharing of understanding.

The history of science fiction unfolds as we gaze at the rare pastel by Margaret Brundage, examine the brushstrokes on the St John, and point to Earl Sherwan's painting for the first Dell paperback (1947) of H.G. Wells's *First Men in the Moon*, with lettering by Sherwan's wife Marguerite. Of course, we keep copies of pulp magazines and paperbacks nearby, to help tell the tales, as it were, as we speak of the transition from serialized novels in tabloid newspapers to the pulps to paperbacks.

On the marble ledge below the paintings rests the complete set of sixteen interior watercolour illustrations done by J.R. Weguelin for H. Rider Haggard's novel *Montezuma's Daughter* (see page 32) when it first appeared, serialized in weekly issues of *The Graphic*, a London tabloid newspaper, during 1893. Because these lovely paintings would not do well in the light and are rather fragile, they are

Virgil Finlay: ***Mistress of Viridis***, cover for *Other Worlds* (June 1956). Oils.
12in x 9in (30cm x 23cm).
Reproduced by kind permission of Lail Finlay Hernandez.

Below
The Wall of Fame.

J.R. Weguelin: **Montezuma's Daughter**, illustration (one of sixteen) for the novel by H. Rider Haggard published in serial form from 7/1/1893 to 11/11/1893 in *The Graphic*.
Watercolour and ink/wash.
9 in x 13½in (25cm x 34cm)
Reproduced by arrangement with the Frank Collection.

kept in a custom-made folio leather case, right next to the bound edition of all the issues of *The Graphic* in which the illustrations appeared.

The Weguelins have a fascinating story of their own. We bought them in 1997 from an American book dealer who had not long before bought them on a buying tour in England. How they came to be in England at that time is a mystery. Two weeks after we had acquired the watercolours, Howard opened the 1975 *Fantasy Collectors' Annual* – randomly pulled from the shelves – and by amazing coincidence found there photographs of them by the New Jersey collector and book-dealer Gerry de la Ree; Gerry reported acquiring the originals 'a few years ago'. So at that time they had certainly been in the States. Then again, how they had got to the States in the first place is equally mysterious!

A good friend and Haggard expert, Al Tella, recalled a vague reference to the paintings in a book by Lilias Rider Haggard, Haggard's daughter, *The Cloak That I Left* (1951). These paintings may at one time have hung in Haggard's study in Ditchingham, England, but we haven't tried to pin that down definitively.

The patterns and interactions between paintings – created by their colours, textures, sizes and qualities – are very important to us. On those rare occasions when a new acquisition forces us to rethink the display on the Wall of Fame, the rearranging of the paintings can take us hours. As noted, such events are rare: a new acquisition must be very special indeed if it is to rival the standard – or enhance the visual composition – of the art that is already there on the wall.

J. Allen St John:
Buccaneers of Venus, cover
for *Weird Tales* (January 1933)
illustrating the lead story by
Otis Adelbert Kline.
Oils on canvas.
25in x 23in (63cm x 58cm)
Reproduced by arrangement with the Frank Collection.

To give an example, when J. Allen St John's *Weird Tales* cover illustration for Otis Adelbert Kline's *Buccaneers of Venus* arrived, we discovered it had special lighting requirements to be seen at its best. This required us to move Earle K. Bergey's *Thrilling Wonder Stories* cover illustration for Albert de Pina's *Princess of Pakmani* to the end of the wall, and that in turn compelled us to redesign three further wall arrangements and to move at least half a dozen other paintings 'down the hall'.

J. Allen St John's *Buccaneers of Venus* came to us in a most unusual way – via a complex trade-off that involved another painting and three other collectors plus plenty of money and time. Before our deal was done we had been offered a dustwrappered first edition of Edgar Rice Burroughs's *Tarzan of the Apes* (1914) in trade for money and a painting which would then be bartered for two other paintings to go to another collector. That particular deal never came to fruition, but a third collector arrived with another proposition... In his *A Bibliographic Dictionary of Science Fiction and Fantasy Artists* (1988) Robert Weinberg relates that this particular painting went from the author, Otis Adelbert Kline (who was given it by the publisher), to a Chicago book store, from there to a Chicago collector (the painting was then priced at $100!) and – by 1985 – to an art dealer in Atlanta. Needless to say, it travelled a bit after that . . . and finally it joined our collection. Until the last minute neither of us had believed that it would happen, and when it did we were amazed. The painting was fabulous. It instantly became one of our favourite St Johns.

Earle K. Bergey: **Princess of Pakmani**, cover art for *Thrilling Wonder Stories* (Summer 1944) illustrating the lead story by Albert de Pina. Oils on canvas. 26in x 18in (66cm x 46cm). *Reproduced by kind permission of the artist.*

We have special regard for Bergey's *Princess of Pakmani*, too, not just because it is a great example of a 1940s handsome sciencefictional hero rescuing a prototypical beautiful redheaded damsel in distress, but also because it was the very first 'real' painting we bought (see page 11), and symbolizes, to us, the serendipitous and often amusing ways we have added works to our collection over the years. We like it as much today as we did when we first saw it: it's one of those paintings that will never leave our walls except for a temporary trip to a museum or gallery show. As noted, we acquired it during one of our early visits to Gerry de la Ree. When Gerry, in what might have been a temporary lapse of sanity, offered it to Jane for a bargain price the deal was settled almost before he'd finished saying the words.

That act of generosity was duplicated twenty-five years later when – desperately ill – Gerry again asked us to come to visit and, perhaps, purchase some art. We departed at the end of the trip with a huge hoard of Finlays, Boks and other masterpieces. It was sad seeing those wonderful paintings that Gerry had assembled over the years leave his house but, as he himself remarked, they were going to a good home – he was satisfied that we would care for them well.

There are two colour paintings by Frank R. Paul (we own three, all told) on the Wall of Fame. Paul was one of the most influential cover artists of the first half of this century. His work decorated science-fiction stories even before the sf magazines came into existence; in the 1920s he was the premier illustrator for *Amazing Stories*, the first such magazine. He carried on his work in the *Wonder Stories* magazines of the 1930s and for many others in the 1940s and 1950s. His images of spaceships and of outer space, of otherworld creatures and of adventures on this world sparked readers' imaginations for many decades. *Universe in Darkness* is fallout from our search for the 'perfect Paul', a search we may never complete because of the market rarity of truly great Paul paintings.

Abduction of Big Red shows Paul's ability to paint something as seemingly absurd as giant chickens and to imbue them with the same range of fears and threats their human counterparts experience. Note the air of danger. Note the evil alien in the red chicken suit. Note the damsel in distress. The painting hangs on our Wall of Fame right next to *Universe in Darkness*. Alas, two good Pauls do not equal one great one!

And then there is Virgil Finlay's *Mistress of Viridis* (see page 31). Finlay was known both for his incredible pen-and-ink drawings and for his colour covers. We acquired this extraordinary painting at the Guernseys Ackerman auction in 1987. Since then nearly every major collector who has seen it on the Wall of Fame has tried to buy it or trade for it from us. Our standard answers alternate between 'No way' and 'Hell no!', depending on how irritated we are by the offer. Otherwise perfectly polite collectors become obnoxious when seeing this painting. We understand why. It is a perfect gem, with the quintessential 'Finlay Femme' in the quintessential Finlay pose.

Allen Anderson's *War Maid of Mars* (see page 36), done as a *Planet Stories* cover, is another piece we are proud to own. *Planet*

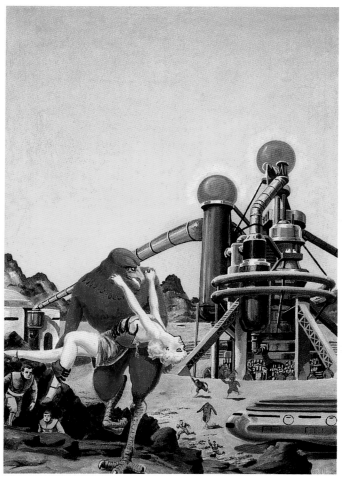

Stories covers were the embodiment of pulp science fiction. These timeless illustrations could have been published in the 1930s, 1940s or 1950s. We own two Anderson paintings, which we bought as a pair from Kelly Freas, another great sf illustrator. It was a tough negotiation. Kelly wanted what seemed to be an outrageous price for them – the absurdity of his asking price was the talk of the convention we were at. However, a week later Jane called him back, and we have never once regretted buying them. Interestingly, we later learned from Weinberg's *A Bibliographic Dictionary of Science Fiction and Fantasy Artists* that Kelly had purchased these two from Fiction House, the publisher of *Planet Stories*, who subsequently, when going out of business, had their workers burn all the original art stored in the warehouse... so these are thought to be the only paintings by Anderson still in existence. His art represented the end of the pulp illustration phase; Freas, the one-time owner of these, was in the vanguard of a new, more modern look in illustration.

A final painting of note on the Wall of Fame is Margaret Brundage's *The Altar of Melek Taos* (see page 38), done as a cover for *Weird Tales*. Brundage was one of *Weird Tales*'s most successful cover artists of the early 1930s. Because of the pastel techniques she used, few of her paintings have survived, and the discovery of a new one would be a major event. This painting had been miserably treated by the time we first saw it at the Ackerman Auction of 1987,

Left
Frank R. Paul: ***Universe in Darkness***, cover for *Future Fiction* (November 1940) illustrating the lead story by J. Harvey Haggard.
Oils on canvas.
23in x 16in (58cm x 41cm).
Reproduced by arrangement with Forrest J. Ackerman.

Above
Frank R. Paul: ***Abduction of Big Red***, cover for *Science Fiction* (October 1940).
Oils.
26½in x 18in (67cm x 46cm).
Reproduced by arrangement with Forrest J. Ackerman.

and we were very disappointed. Fortunately, we decided to bid for it anyway. Once we had got it home, Jane found an incredible art restorer who specialized in pastels. Working with a razor blade, a fraction of an inch at a time, he removed the painting from the acidic backing to which it had been glued. He repaired small tears and removed the tape used to fasten the picture into its frame. At the end of his efforts, we had a magnificent painting – one of the most significant in the field. What's more, we had recovered a great work that otherwise would have been doomed to destruction.

Very occasionally a new treasure will be lodged temporarily on one or both of two dining-room chairs which are otherwise rarely used. In such cases the chairs function as easels, propping up paintings that are, as it were, in a holding pattern, waiting for their new – and more or less permanent – home. The habit of employing seldom-used chairs in this fashion is one that we have retained from our earliest days of collecting, when wall space was in short supply. As of this writing, one chair is being used to display a large and fancifully erotic piece titled *The Garden of Eden* (1956) by Mahlon Blaine (which, incidentally, came from our second 'art' visit to Gerry) and the other a recently framed early (1936) Leo Morey watercolour cover for *Amazing Stories* called *Twin Worlds*, done to illustrate the story by Neil R. Jones, Eando Binder and Stanley G. Weinbaum. Sometimes, as in the case of the Blaine, we just end up liking the look of a painting as it sits in its 'temporary' place on a chair and so it remains there: the Blaine has occupied its current position for almost four years now, and we have no immediate intention of moving it.

Running the length of the wall, and marking the boundary of the opposite side of the room, there is a series of storage cabinets topped by a continuous ledge of rose-coloured marble. This offers a wonderful display area for small sculptures and other *objets d'art*. Among the artefacts to be found here are figural works in bronze, resin and marble, as well as an assortment of crudely designed – but fun to pick up and look at – props from movies such as *Flash Gordon* (1980), *The Land That Time Forgot* (1975) and *Erik the Viking* (1989). Such entertainingly 'decorative' items, rather formally displayed here, are strewn fairly casually elsewhere about the house. They also tend to be rather peripatetic, since a vacant corner which on a Monday might seem the ideal place to lean a six-foot fake-fur-topped battleaxe may be needed on a Tuesday for a quite different work of art.

Many of the pieces we own have a story attached to them, and these movie props are no exception. They were purchased as part of two large crates of such stuff we bought at a Christies auction in London. Each crateful was acquired as a separate lot – hoping to win at least one we had posted absentee written bids for several, and ended up with the two. Our closets are still overflowing with the remains of this purchase, even though for several years after that auction our friends received the most unusual Christmas gifts. (Would anyone like a drum from the movie *Revolution*?)

At one time the Wall of Fame could have held all of our 'classics', but paintings of similar quality to those in the Dining Room now

Facing page
Allen Anderson: **War Maid of Mars**, cover for *Planet Stories* (May 1952). Oils.
20in x 14in (51cm x 36cm).
Reproduced by arrangement with the Frank Collection.

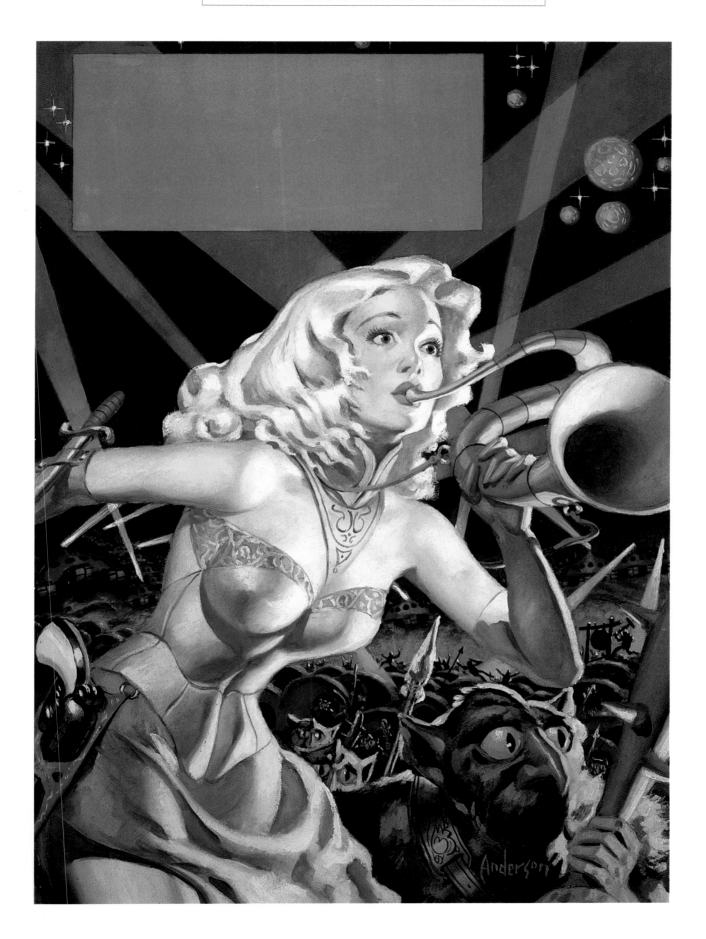

Margaret Brundage: ***The Altar of Melek Taos***, cover for *Weird Tales* (September 1932).
Pastels.
20in x 17½in (51cm x 44cm).
Reproduced by arrangement with the Frank Collection.

overflow into Pulp Hall and the Stairwell, and then into adjacent halls, their precise homes being determined by many factors but notably age and quality. Some have begun to make their way to the Reverence Room. There have had to be similar demotions of our contemporary work from some of the other prestigious sites – such as the Entrance Hall, the Kitchen and the Master Bedroom.

Because in most cases the artists concerned are not only living but also our friends, it's sometimes difficult not to hurt their feelings. It can be difficult to persuade them that rehanging is just one of the exigencies of dealing with such a large collection. We once heard one well known artist remark ruefully to another: 'I used to be in the Kitchen, but now I'm in one of their bathrooms.'

CHAPTER 4

PULP HALL AND STAIRWELL

WHEN THE Wall of Fame was still big enough to hold all of our great classic pulp art, the barren walls of the hallway and 'back' stairwell represented a vast, untapped family treasure. In the houses we have had, bare walls are major assets which – once spent – can rarely be recovered. This has been the story of the Pulp Hall.

One by one, paintings of similar quality to those on show in the Dining Room overflowed into the hallway and then spread to the stairwell and its great two-storey wall. At one time Robert Fuqua's fabulous 1944 painting *The Mad Robot* was at the centre of the Wall of Fame. When we acquired our first J. Allen St John painting, *It's a Small World* (not shown), the Fuqua was uprooted – forced out of

Robert Fuqua: ***The Mad Robot***, front cover for *Amazing Stories* (January 1944) illustrating the lead story by William P. McGivern. Oils.
20in x 14in (51cm x 36cm).
Reproduced by arrangement with the Frank Collection.

Robert Fuqua: **Death of the Moon**,
back cover for *Amazing Stories* (January
1944) illustrating the feature article by
Morris J. Steele, `Stories of the Stars'.
Oils.
20in x 14in (51cm x 36cm).
*Reproduced by arrangement with
the Frank Collection.*

It's rare to obtain the illustrations for
both the front and the back covers of a
single issue of any pulp magazine, so
when, some time after we'd bought the
front cover, the opportunity arose to
acquire the back, we couldn't resist.

that room and onto a wall in the Pulp Hall. When, eight months later,
we were fortunate enough to acquire Fuqua's *Death of the Moon*,
the back cover for the same issue of the magazine, suddenly *The
Mad Robot* had a neighbour. Then, shortly after our first St John had
pushed the Fuqua out, it shared the Fuqua's fate. The perpetrator?
Another J. Allen St John painting, *Tarzan and His Mate* (see page
15), based on the Edgar Rice Burroughs characters.

Originally titled *Ape Man and Mate*, for copyright reasons, this
was commissioned by (and inscribed to) Vernell Coriell, then

President of the Burroughs Club. It was reproduced in black and white on the cover of Coriell's special re-issue of the first twelve issues of *The Burroughs Bulletin*, appearing in both hard and soft covers. Sometime in the early 1960s it was published by Russ Cochran as a full-colour lithograph in a limited, numbered edition of 950, signed 'Vernell Coriell, House of Greystoke'. However, it was not until 1995 that its second owner was willing to part with the piece, and we were fortunate to be offered the opportunity to acquire it.

Painted almost impressionistically – in a loose, poetic style reminiscent of St John's contemporaries who worked in the tradition of Howard Pyle's Brandywine School – *Tarzan and His Mate*, a rarely seen masterpiece, is testament to St John's superlative narrative ability to stir the imagination. If you look carefully you can see clear evidence that pencil sketching preceded the paint. St John's

Lawrence Sterne Stevens: **Ship of Ishtar**, cover for *Fantastic Novels* (March 1948) illustrating A.A. Merritt's famous novel.
Oils on canvas.
22½in x 20½in (57cm x 52cm).
Reproduced by arrangement with the Frank Collection.

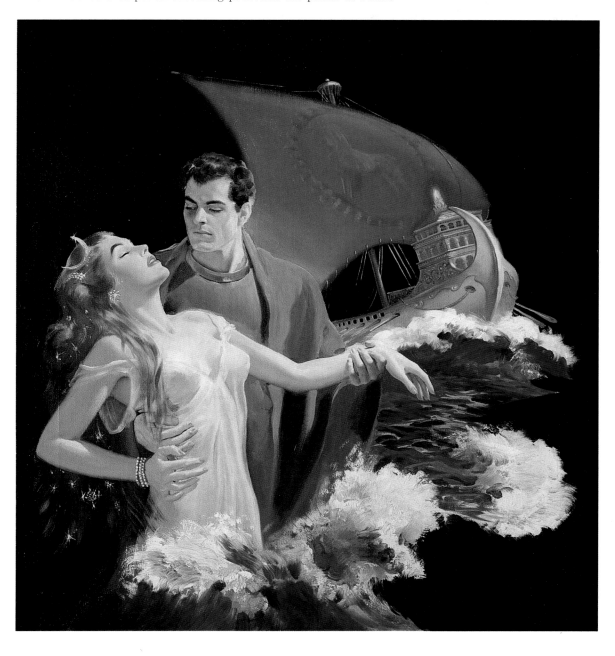

Facing page
Norman Saunders: ***Newscast***,
front cover for *Marvel* (April/May
1939) illustrating the lead story
by Harl Vincent.
Oils on canvas.
28in x 18½in (71cm x 47cm).
*Reproduced by kind permission of
Ellene Saunders.*

Perhaps anticipating our modern-day
preoccupation with cosmetic surgery,
this painting reflects the concern in
the late 1930s about uncontrolled
technological advances, a 'new world'
captured by exhibits at the 1939
World's Fair.

J.R. Forte: ***Once in a Blue Moon***,
cover for *Future Magazine*
(August 1942) illustrating the lead
story by Norman L. Knight.
Oils on canvas mounted on board.
30in x 20in (76cm x 51cm).
*Reproduced by arrangement with
the Frank Collection.*

Immediately after this painting arrived it
went to our restorers. Oh, how beautiful
the colours were after a good cleaning!

purposeful misproportioning of the 'mate' in comparison to the apeman gives a magical delicacy and subtle intensity that is rarely found in other Tarzan interpretations.

When our second buying visit to Gerry de la Ree's home led to the arrival of a carload of fine classic art, we knew that the empty great wall of the stairwell was about to go the way of all the other once-bare spots. That day, we drove home with six Virgil Finlay covers, another half-dozen Hannes Bok paintings, four rare proofs (some dedicated to Dunninger the Magician) of Bok's series of lithographs, *The Four Powers*, the Lawrence Sterne Stevens painting for A. Merritt's *Ship of Ishtar*, a number of black-and-white Bok and Stevens drawings, a compelling Jeff Jones oil painting and several other pieces.

Then an auction brought us *Newscast*, Norman Saunders's front cover for the April/May 1939 issue of *Marvel*. And a purchase from a book-dealer at a science-fiction convention captured the cover (artist unknown) of the 1956 Ace paperback edition of Philip K. Dick's *The World Jones Made*. Other purchases, in no short order, yielded Howard W. McCauley's *The Cosmic Bunglers* (see page 15) plus two other McCauleys of the 1950s. Paintings by J.R. Forte for a 1942 *Future Fiction* cover, *Once in a Blue Moon*, and by Gabriel H. Mayorga for a 1940 *Super Science* cover, *Juice* (see page 10), followed, then another St John and…

Our cup overflowed! For the Pulp Hall and Stairwell we'd discovered a new kind of wallpaper – art. In these areas blank spaces came to be considered the rare and unusual, and Howard's athletic ability to hang paintings while perched with one foot on a ladder and the other suspended in midair became just as important as our aesthetic abilities when it came to putting together paintings whose themes and feelings would reinforce and complement each other. Fortunately, the latter task is not as difficult as it might seem when you're dealing with pulp art of the 1930s, 1940s and early 1950s, because these classical works tend uniquely to represent the look and feel of their time, and so are usually instantaneously recognizable as such. For this reason it's possible to consider 'time period' alone as a unifying theme, whether the painting be of a giant robot or of a giant octopus, a green one-eyed barbarian or a lovely girl falling off the Earth, a spaceship blazing through hard vacuum or a battleship ploughing through the waters… Whatever the subject matter, the artworks fit well together, as if they had been painted to hang side-by-side.

Nonetheless, there is some reasoning to our rhyme for the placement of paintings on these walls. The two Fuquas are hung together for logical reasons, as are Saunders's *Newscast* and *The World Jones Made*. While no one has been able to pinpoint the artist who did this latter, various experts having suggested either Norman Saunders or Robert Schultz, we believe it was Saunders who painted this piece, a conclusion we reached after comparing it with the certainly

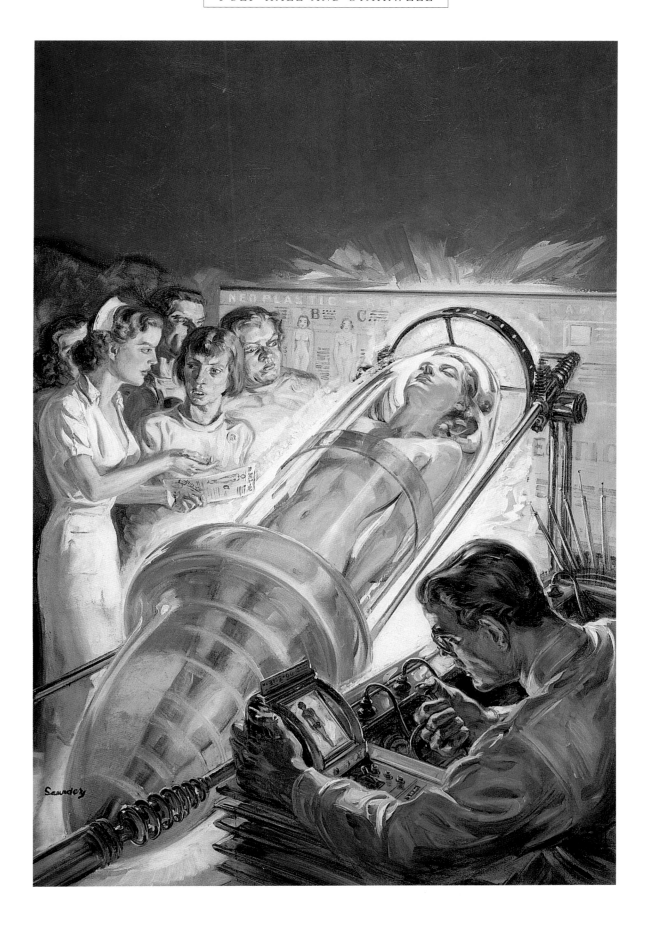

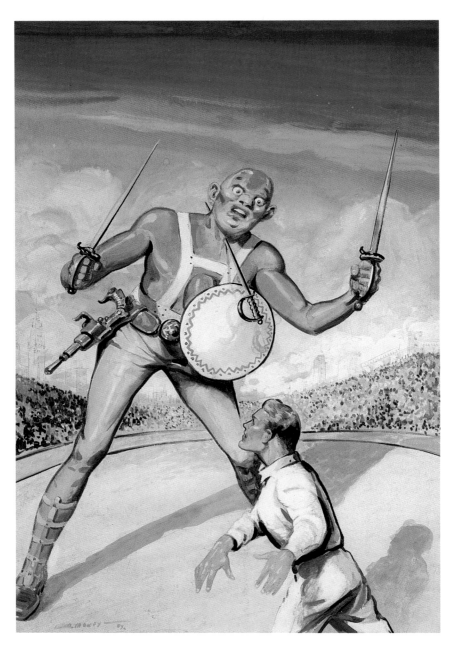

Leo Morey: *Giant of Ganymede*, cover for *Amazing Stories* (December 1946) illustrating the lead story by Ross Rocklynne.
Gouache on board.
19in x 13¼in (48cm x 37cm).
Reproduced by arrangement with the Frank Collection.

Roy Krenkel: *Hadon of Ancient Opar*, cover for the novel (Daw, paperback) by Philip José Farmer, 1974.
Oils on canvas board.
24in x 16in (61cm x 41cm).
Reproduced by arrangement with the Frank Collection.

attributed *Newscast*. Although separated by fourteen years, different pulp and paperback publishers, story theme and mood, both paintings show similar stylistic touches – in the folds of clothing, the shadows cast by figures, and the broad brushstrokes.

The centre of the huge two-storey Stairwell wall is just the space for the eye-popping, colour-dazzling, lavish works of McCauley, Forte and Mayorga. Surrounding these are somewhat more subdued but no less appealing pieces by Julian S. Krupa, Leo Morey, Lawrence Sterne Stevens, Hannes Bok and Jeff Jones. As we descend towards the lower levels, the art moves from spaceships and hard science towards barbarians, warriors and fantasy. This transition becomes complete at the bottom of the stairs, where works by Jones, Roy Krenkel and then Frank Frazetta appear. These works guide the tourist into an anteroom that serves as introduction to the Master Library and Living Room.

CHAPTER 5
JANE'S OFFICE AND ENTRY

WHEN PURCHASED, the house contained one master bedroom and a large second bedroom on the same main level. This second room, however, has never been used as a bedroom during our tenure – unless one counts the sleep-sofa which has, upon occasion, been used for family visits and weekend guests. Instead it functions as an office for Jane, who runs her business (the art agency Worlds of Wonder; see www.wow-art.com) from here. However, as well as the computer, filing cabinets, copy machine and all the other accoutrements you'd expect to find in an office, there is artwork covering every available wall and flat surface, not to mention the walls of the hallway that serves as entry.

The art is chosen according to Jane's own personal tastes, which tend towards tightly rendered fantasy of a particular sort: more or less realistic interpretations of stories that are touched by humour, surrealism or whimsy. Jane has a soft spot that translates into a fondness for strange critters, especially those which seem familiar and could be friendly but are actually imaginary/unearthly in their

James Warhola: ***Callahan's Lady***, cover for the story collection (Ace, paperback) by Spider Robinson, 1989. Oils.
22in x 28in (56cm x 71cm).
Reproduced by kind permission of the artist.

We were entertained by this painting at first sight, and had great times discovering all the cleverly hidden – and not so hidden – imagery.

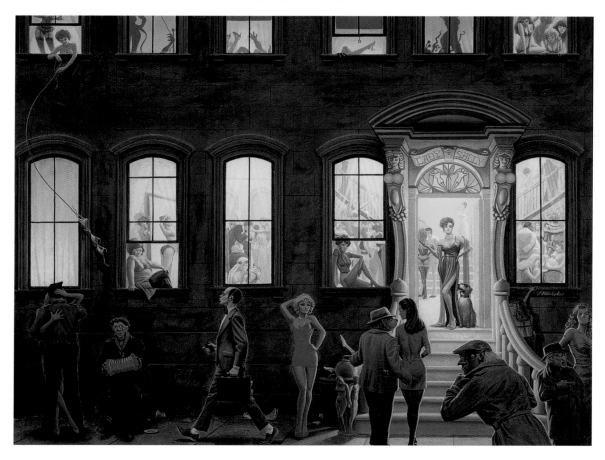

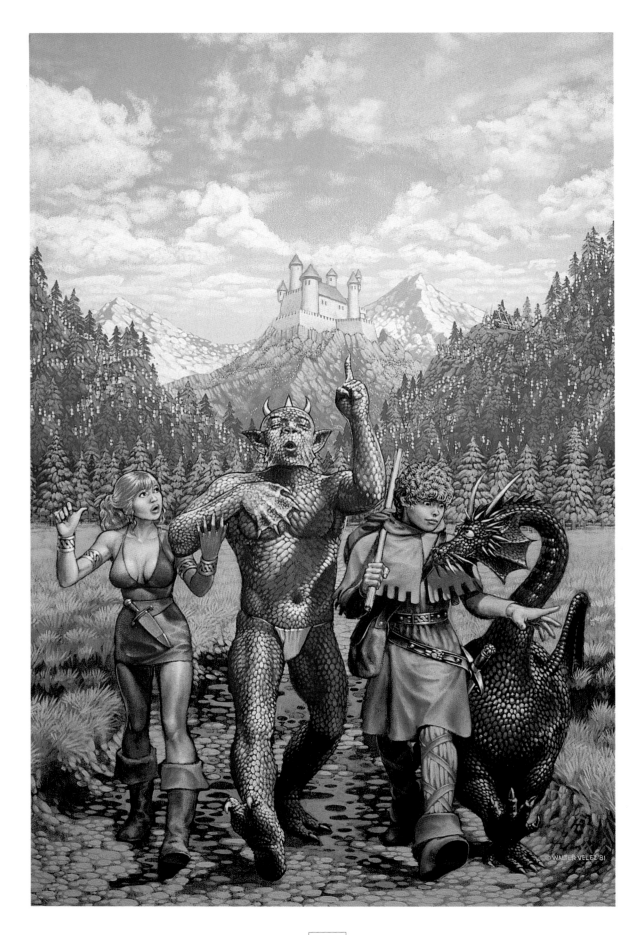

Below
Thomas Kidd: ***Sourcery***, cover for the
novel (Signet/NAL, paperback) by Terry
Pratchett, 1989.
Oils.
24in x 18in (61cm x 46cm).
Reproduced by kind permission of the artist.

We liked this painting a lot when we first
saw it but pointed out to Tom that there
seemed to be something missing at the
top. When we saw it again Tom had
painted in the terrific critters along the
beam. We bought the painting on the
spot!

Left
Romas: ***The Broken Goddess***,
cover for the novel (Roc, paperback)
by Hans Bemmann, 1993.
Acrylics.
30in x 19in (76cm x 48cm).
Reproduced by kind permission of the artist.

origins. She also likes things that are entertainingly bizarre, colour-
fully grotesque, exotically alien or darkly humorous. Her favourites
contain all of these elements.

James Warhola's cover art for Spider Robinson's story collection
Callahan's Lady, Walter Velez's for Robert Asprin's novel *Another
Fine Myth...*, Tom Kidd's for Terry Pratchett's *Sourcery*, Romas's
for Hans Bemmans's *The Broken Goddess* and James Gurney's for
Alan Dean Foster's *Quozl* are the kinds of paintings that are dear to
Jane's heart. They are attractive, confidently painted images with
clearly defined and well implemented characters. Mice, rabbits,
dogs – even ancient marble statues – all dressed up with somewhere
to go, and something to do, are her cup of tea... although it should
be mentioned that Gurney's (or, rather, Foster's) large rabbit-like
creatures were not rabbits at all but alien creatures who were

Facing page
Walter Velez: ***Another Fine
Myth . . .***, cover for the novel
(Ace, paperback) by Robert Asprin,
1981.
Acrylics on canvas.
30in x 20in (76cm x 51cm).
Reproduced by kind permission of the artist.

James Gurney: **Quozl**, cover for the
novel (Ace, paperback) by Alan Dean
Foster, 1989.
Oils.
18in x 24in (46cm x 61cm).
Reproduced by kind permission of the artist.

It has always amused us when artists
immortalize their family members,
professional colleagues and artist friends
in their paintings. Here Jim has elected
James Warhola as Man of the Year in
his likeness of the artist at the bottom
left-hand corner.

shocked to discover earthly bunnies and humans' attitudes
toward them.

Warhola's painting (not shown) for Robert Asprin's *Phule's
Company* (1990), Gurney's *Culture Shock* (see page 52), and Ian
Miller's *Dog Bite* at first glance would seem to have little in common,
but all play games with viewers' minds – in particular with our
views towards war.

Warhola's genius for characterization is evident in *Phule's
Company*, which seems to be a take-off of a popular American TV
show of old, *F Troop*, but transported to outer space and populated
by a company of alien misfits and clowns.

Gurney's assignment for *Culture Shock* – the painting was
originally done as the cover for John Dalmas's *Homecoming* (1988)
– was, it seems clear, to interpret the book by capturing the clash
between peace-loving off-world colonists and the Middle Eastern
barbarian empire they face on their first expedition back to Earth.
The nonsensically designed spaceship of the picture, however,
reduces the expeditionary force to the same level of primitivism as
the 'natives'

Miller's painting, *Dog Bite*, offers a more potent and disturbing
image. The artist spares nothing in his satirical pokes at the masks
we wear for battle and the standards the 'tin men' of war display
on the social (as well as the actual) battlefield. Miller's motifs –
walking trees, insects, dogs, toy soldiers and toys – are all oddly

Ian Miller: ***Dog Bite***, private
commission, 1994.
Acrylics and inks.
16in x 24in (41cm x 61cm).
*Reproduced by kind permission of
the artist.*

Left
Richard Hescox: ***Omens of Kregan***,
cover for the novel (Daw, paperback)
by Dray Prescot (Kenneth Bulmer),
1985.
Acrylics.
32in x 28in (81cm x 71cm).
*Reproduced by kind permission
of the artist.*

Below
Stephen Hickman: ***The Dragon
Hoard***, cover for the paperback
re-issue (Ace, paperback) of the
novel by Tanith Lee, 1985.
Oils.
45½in x 23in (116cm x 58cm).
Reproduced by kind permission of the artist.

This painting was also used as the
cover for *Adventures Comic #8*
(September 1987).

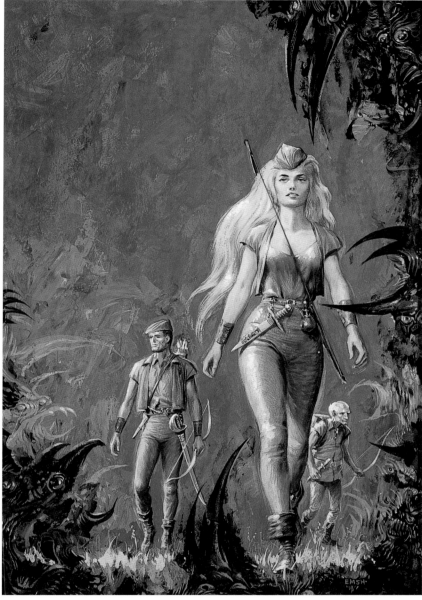

Left
Ed Emshwiller (Emsh): **Glory Road**,
cover for *The Magazine of Fantasy &
Science Fiction* (June 1963) illustrating
the novel by Robert A. Heinlein.
Oils.
15½in x 10½in (39cm x 27cm).
*Reproduced by kind permission of
Carolyn F. Emshwiller.*

We have been told by Andrew Porter,
publisher of *Science Fiction Chronicle*,
that this was the first piece of original
colour art to sell at a science-fiction
convention auction for over $100: at
the first DisCon auction in 1963 it
sold for $110.

Facing page
Kelly Freas: **Lord of the Green
Planet**, cover for the novel (one
half of an Ace Double, paperback)
by Emil Petaja, 1967.
Oils.
14½in x 9¼in (37cm x 23cm).
Reproduced by kind permission of the artist.

We exhibited this painting at a
convention retrospective of Kelly's
works. When Kelly saw it he remarked
that he too liked that painting, because
he had used his daughter and their
28lb (12kg) Siamese cat as the models.

portrayed in an incredibly tight, pointedly dark Gothic style. The artist sees a world where social conventions are turned topsy-turvy and where tiny scavenging dogs pick over a fallen rag doll. Because such strong images are often discouraged by publishers, sometimes the only way to guarantee their existence is through private commission (which this painting is).

Richard Hescox's cover for Dray Prescot's *Omens of Kregan* and Steve Hickman's cover for Tanith Lee's *The Dragon Hoard* (see page 49) are noteworthy not only because they carry out their themes so well but because of the time and effort that have gone into their creation. You can count every bronze tile in the mosaic that forms the backdrop for Hescox's throne room, and see every detail in Hickman's gold coins littering the floor under the dragon's tail. Bearing in mind the short schedules and strict deadlines that force most commercial artists to limit their efforts, it is a wonder that contemporary illustrative art of this quality exists.

Above
James Gurney: **Culture Shock**,
cover for the novel *Homecoming* (Tor,
paperback) by John Dalmas, 1984.
Oils.
22in x 13in (56cm x 33cm).
Reproduced by kind permission of the artist.

Right
Ed Emshwiller (Emsh): **Slavers of
Space**, cover for the novel (one half
of an Ace Double, paperback) by
John Brunner, 1960.
Acrylics.
17in x 12in (43cm x 30cm).
*Reproduced by kind permission of
Carolyn F. Emshwiller.*

James Bama: **The Golden Ogre**,
cover for the novel (Bantam, paperback)
by Kenneth Robeson, 1969.
Oils.
19in x 12in (48cm x 30cm).
Reproduced by kind permission of the artist.

Although it suffers from some rubbing
and abrasions where the painting was
taped by the art director prior to pho-
tographing for reproduction, this is a
classically realized Doc Savage painting
by the artist whose name will always be
associated with the character.

The works displayed in the entry to Jane's office, in addition to offering strong and colourful images, have a common artistic attribute. They are notable for having a readily identifiable 'visual signature' – a style of expression that is uniquely the particular artist's own. This is a key characteristic shared by all the art that Howard and Jane collect, and a key determinant of the artists whose works they choose to acquire. The observation is as true for the contemporary art as for the 'vintage' art – by Kelly Freas, Jack Gaughan (not shown) and Ed Emshwiller, popularly known for his signing as Emsh – that is on view in the entryway.

Beyond the requirement that the paintings selected for Jane's office be fun to look at, she judges them on the basis of how well the artist has been able to convey an emotional range and elicit an emotional response. It's not enough for artwork to be attractive, it must have immediacy; it must be involving, tell a story, and tell it quickly. Jane likes paintings with punch, with colour and with a definite point of view.

CHAPTER 6

BALCONY GALLERY

T O THE RIGHT of the entryway an open balcony overlooks the Living Room and the terrace and forest beyond. The Balcony wall, and the gallery space into which it flows, is a perfect home for our more 'funky' art. On this wall, absurd or weird faces peek or glare from pieces such as Jim Warren's original poster art for the 1988 movie *Waxwork* and Gary Ruddell's computer-game box cover for *Shufflepuck*. Here is where Joe DeVito's nightmare version of The Penguin hurls a flock of evil flesh-eating birds at a dark and heroic Batman in *Further Adventures of Batman* and Les Edwards's machine-gun-toting punk fighters battle their scar-faced counterparts in a war-torn apocalyptic *Dark Future Skirmish* while, in Jill Bauman's vision of the future, citizens are more interested in visiting an *Interplanetary Zoo* (see page 55).

But, with all their wild antics, these monsters, knaves, devils, fiends, brutes and heroes can't compete with what waits at the end of the balcony, set in a small gallery outside the Reverence Room and our Master Bedroom. Here is where Joan Danziger, a highly respected mainstream (but at the edge) sculptor, agreed to locate her incredible *Rhinoceros* chaise longue (see page 58).

Several years ago Danziger approached us with a proposition. She showed us a relatively small sculpture (maquette) of a strange bird-headed human creature reclining on a chaise longue shaped in the form of a rhinoceros. 'What you need,' Danziger said, 'is a chair

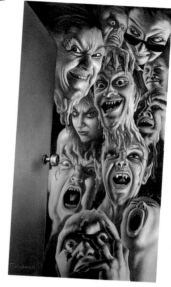

Jim Warren: **Waxwork**, movie poster and videocassette package art, 1988.
Oils.
28in x 18in (71cm x 46cm).
Reproduced by kind permission of the artist.

Below
Gary Ruddell: **Shufflepuck**
Broderbund Games, computer-game box cover, 1988.
Oils on canvas mounted on wood panel.
18 in x 32in (48cm x 81cm).
Reproduced by kind permission of the artist.

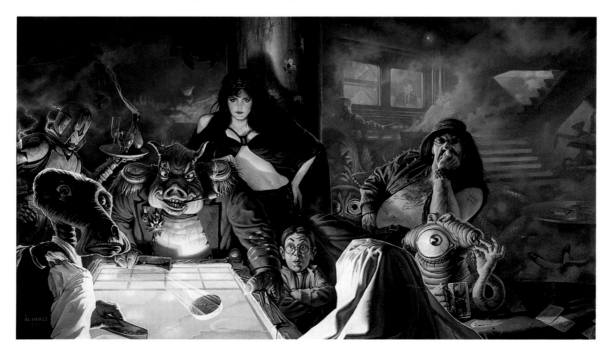

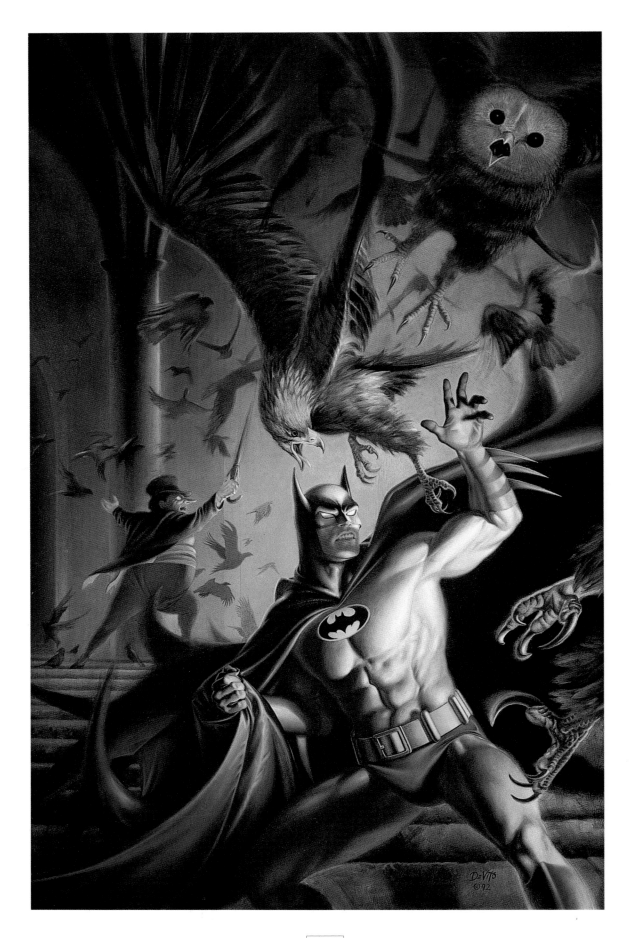

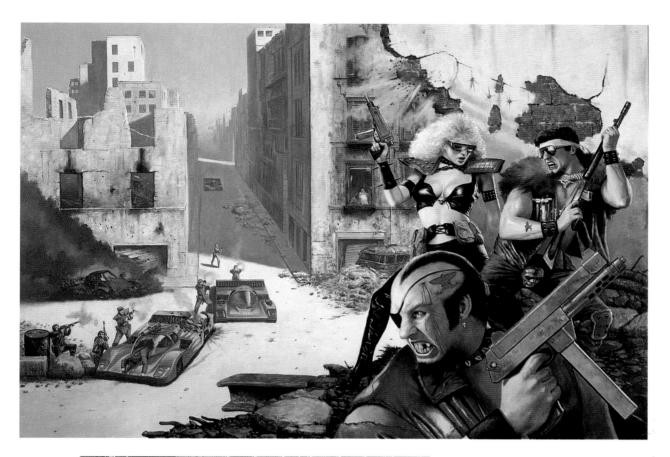

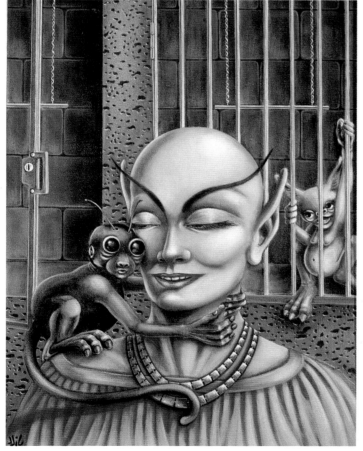

Above
Les Edwards: **Dark Future
Skirmish**, game box cover, 1989.
Oils (alkyds).
24in x 39in (61cm x 100cm).
Reproduced by kind permission of the artist.

Left
Jill Bauman: **Interplanetary Zoo**,
mid-1970s.
Oils.
19in x 14in (48cm x 36cm).
Reproduced by kind permission of the artist.

Facing page
Joseph DeVito: **Further Adventures
of Batman #2: The Penguin**,
cover for the anthology (Bantam, 1993,
paperback) edited by Martin H.
Greenberg, 1992.
Oils.
25½in x 17in (65cm x 43cm).
Reproduced by kind permission of the artist.

Jim Burns: **Seasons of Plenty**,
cover for the novel (HarperCollins
UK, hardback) by Colin Greenland,
1995.
Acrylics.
30in x 40in (76cm x 102cm).
*Reproduced by kind permission
of the artist.*

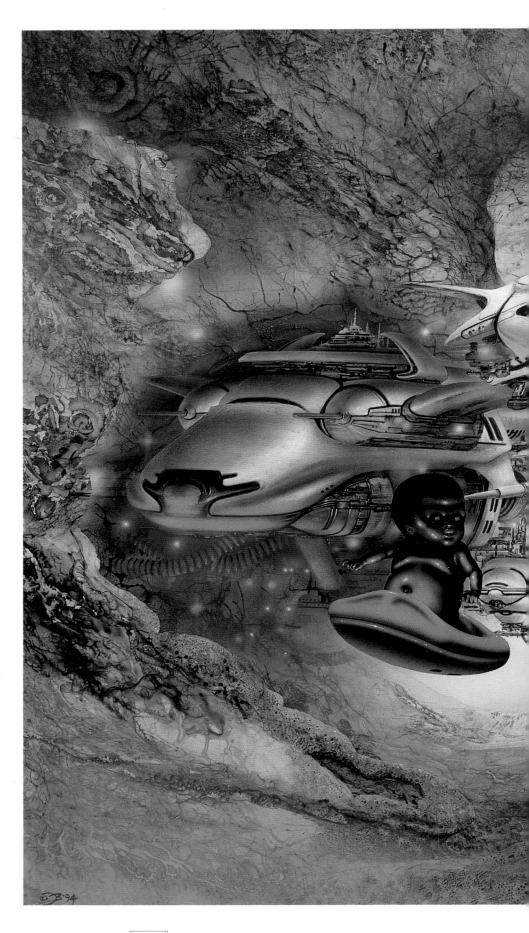

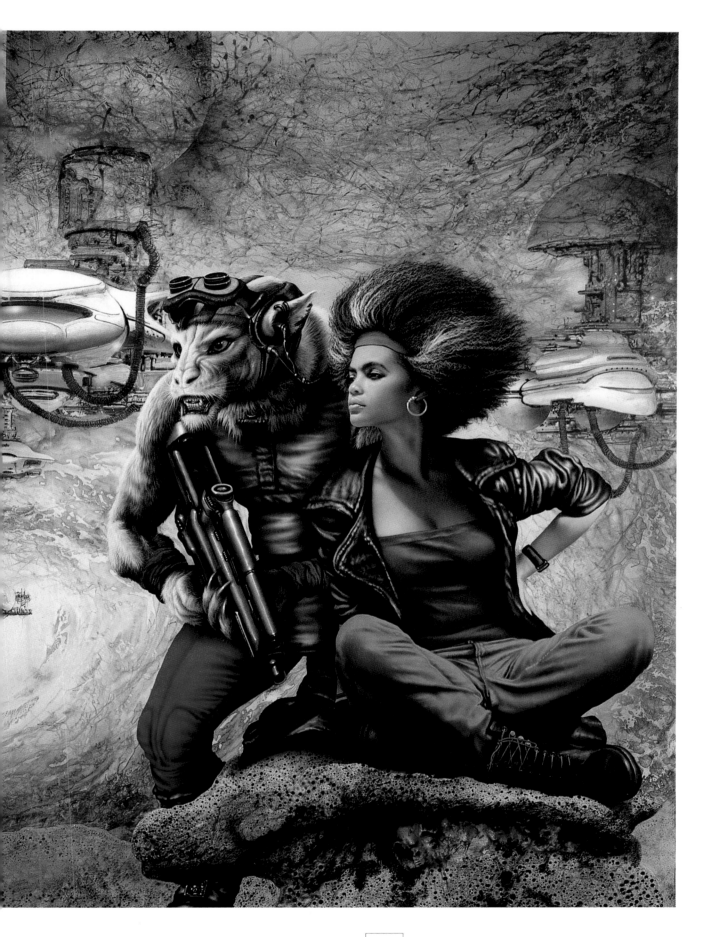

Joan Danziger: **Rhinoceros Chair**,
1992.
Mixed media: leather, wood, metal,
resin-reinforced fabric, celluclay, acrylic,
paint, pencil.
About 4ft x 4ft x 5½ft (120cm x
120cm x 165cm).
Reproduced by kind permission of the artist.

Below
Barclay Shaw: **Eurydice**,
personal work, 1989.
Acrylics.
49in x 30in (124cm x 76cm).
Reproduced by kind permission of the artist.

This painting was displayed at the
Delaware Museum Science Fiction
Exhibition, 1990.

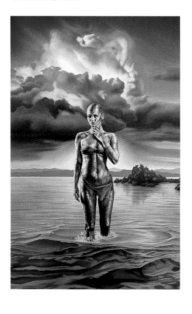

just like this one, but full-sized.' The notion, bizarre as it at first
seemed, became more and more appealing until it became a
full-fledged project. Three years, one nineteenth-century ladies'
fainting chair, three leather hides and one house later, the functional
sculpture was a reality. And just in time, for our new house had a
spot so perfect that it seemed to have been built especially to suit it.

The Rhinoceros Chair is nearly irresistible. At any of our parties
you can always find small groups of examiners and admirers
inspecting its parts. Children and adults alike feel compelled to
recline on this fantasy-animal throne. And invariably they find
themselves wishing also to have their photograph taken there – we
keep a camera handy for the purpose.

The 'creature' theme of the Balcony Gallery is carried further by
two stunning paintings by Jim Burns and Barclay Shaw on the
Gallery's back wall. The Burns painting, the cover for Colin
Greenland's *Seasons of Plenty* (see page 56), portrays a gorgeous
woman warrior of the future (Tabitha Jute) and her rugged
cat-headed male companion; this fighting duo is surely a force to be
reckoned with! The Shaw piece, *Eurydice*, shows an equally beautiful
but this time bikini-clad female standing in the shallow waters of
a quiet mountain-lined bay. When you first look, the woman's love-
liness masks the fact that she is bald and covered from head to toe
in large green scales.

CHAPTER 7

THE REVERENCE ROOM

ONCE UPON A TIME this room was called the Playroom and its floor was strewn with weights and other exercise equipment. Art had made strong inroads, but the main themes of the work on display here were powerful barbarians and well muscled lady warriors – art decor in keeping with the room's function, in fact. Pictures from other rooms wandered down the hallways and some found a resting place in the Playroom rather than in one of our closets. We then noticed that astronomical art looked interesting in this room, probably because of the soft lighting given by the room's glass-block windows and shaded skylight.

A major breakthrough – and the official renaming of the room – came about when we hung an exceptional piece by Chesley Bonestell on the principal wall. The room was transformed instantaneously from a workout room to a space of extraordinary power and beauty – a place where one would feel compelled to be reverential, in the presence of Bonestell's genius and of the magnificent products of that genius. Emptied of distractions – the weights and equipment

Chesley Bonestell: **Saturn Viewed from Titan**, personal work, c.1952. Oils.
23in x 18¼in (58cm x 46cm).
Reproduced by kind permission of the artist's estate.

This is the same view as the famous Plate XXXVI, page 132, in Bonestell's book *The Conquest of Space* (1949; text by Willy Ley). According to Frederick C. Durant III, conservator of Bonestell's estate, this was one of the artist's favourite scenes, and he painted it at least seven times; this one was painted for his daughter, the late Jane Webster, who subsequently gave it to Boyd Jarrell (nephew of William C. Esther, Bonestell curator). Exhibited only once – at the California Academy of Sciences (1988) – this painting is in perfect condition. Never published, it was later photographed for use in an issue of limited-edition facsimile prints.

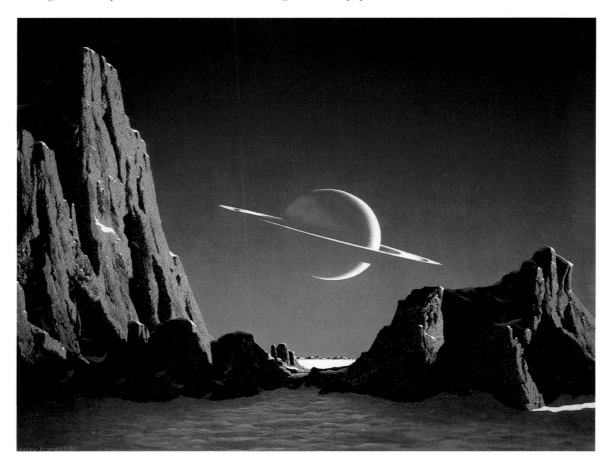

Above
Chris Moore: ***Asimov's Science Fiction Hugo and Nebula Award Winners***, cover for the hardback anthology (Dell UK) edited by Sheila Williams, 1995.
Acrylics.
15½in x 34½in (39cm x 88cm).
Reproduced by kind permission of the artist.

Right
David B. Mattingly: ***The Regiment***, cover for the novel (Baen, paperback)
by John Dalmas, 1987.
Acrylics.
22in x 28in (56cm x 71cm).
Reproduced by kind permission of the artist.

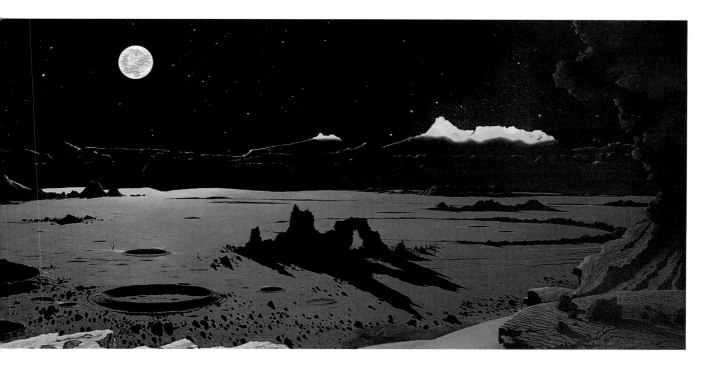

Above
Chesley Bonestell: **Lunar Landscape**,
personal work, 1956.
Oils.
21in x 85in (53cm x 216cm).
*Reproduced by kind permission of the
artist's estate.*

This large painting was the study for
the 8ft x 40ft (2.44m x 12.2m) mural
created by Bonestell for the Hayden
Planetarium, subsequently displayed also
at the Boston Museum of Science and
the Smithsonian Air and Space Museum.
The full-size canvas mural is now in the
Smithsonian's collection but needs
restoration. The painting is astronomically
correct for springtime, when our north
pole is tipped towards the sun.

Left
Alex Schomburg: **Death of Iron**,
cover for *Wonder Stories Magazine*
(Winter 1952).
Oils.
26in x 20in (66cm x 51cm).
*Reproduced by kind permission of
R.A. Schomburg.*

John Berkey: **The Visitors**, personal
work, 1990.
Casein and acrylics.
22in x 30in (56cm x 76cm).

This picture is featured in Berkey's
book *Painted Space: The Art of
John Berkey* (1994).

were moved upstairs to a smaller loft area – the room became the
Reverence Room, now dedicated to astronomical landscapes and
works related to space exploration.

The focal point of the room is still the major painting by Chesley
Bonestell. Bonestell is perhaps the most respected and famous
space artist of them all. His *Lunar Landscape* fills the wall seen
immediately upon entering. The painting is the artist's study for a far
larger mural – 40ft (12.2m) long – now owned by the Smithsonian
Air and Space Museum. This piece, plus two other Bonestell originals
that hang here, form the perceptual centre around which other
space paintings – chosen for their astronomical subject matter or
their hard sciencefictional themes – have been added over time, to
extend and maintain the overall concept.

Not long before he died the artist Paul Lehr caught something of
the emotions engendered by this painting: 'When my wife Paula and
I first visited the collection of Howard and Jane Frank several years
ago I was swept off my feet by its diversity and complexity. I had
never viewed science fiction and fantasy art displayed with more
attention in real surroundings. I will never forget the beautiful moon-
scape by Chesley Bonestell displayed in a room of its own, drenched
in soft grey daylight from the ceiling, as though I were standing there
on the surface of the moon itself.'

This is a guest room that sees few guests. It is sparsely decorated,
with carpeting in grey and walls of white. The overall effect is one of
stillness and contemplation, which complements the exceedingly
strong visual effect of Bonestell's moonscape, which is why this
painting works so well here. Moreover, the natural lighting in the
room is indirect – another good reason for placing the painting here
was that it would not be injured by direct sunlight. Through the use
of artificial lighting, however, *Lunar Landscape* can be made
to seem as if responding to the light of noonday or twilight, and most
viewers find the emotional effect quite powerful. You definitely
feel humbled when confronting the sunstruck cliffs, the deeply
shadowed canyons and the enigmatic *maria* of Bonestell's hypothet-
ical lunar landscape.

CHAPTER 8

MASTER BEDROOM SUITE

WE DON'T consciously make an effort to shock people, yet visitors are invariably surprised by the art we choose to display in our bedroom and bathroom. They understand that this suite functions primarily as a 'private' space, although we don't make absolute distinctions between 'private' and 'public' spaces where our collection is concerned. We are fond of the art in our bedroom, so many (but not all) guests are invited to tour it and the bathroom, in the same way we invite them to tour the library. The unprepared tourist is frequently disconcerted by our rather idiosyncratic choices.

A lot of the stuff strikes people as being downright sexy, erotic or, at the very least, sensual. Some is provocative, some is serious,

Above
Lorraine Vail: ***Pet***, personal work, 1996.
Handcast bronze.
42in x 15in x 35½in (107cm x 38cm x 90cm).
Reproduced by kind permission of the artist.

Left
H.R. Giger: ***Biomechanoid II, Work #521***, 1975–83.
Acrylic on paper on wood.
39in x 27in (100cm x 70cm).
Copyright © 1999 H.R. Giger (Fine Art).
Reproduced by permission.

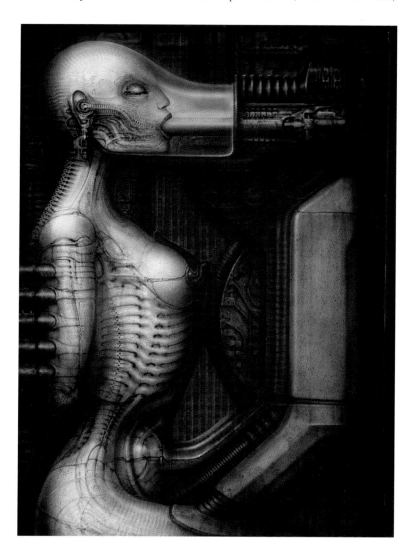

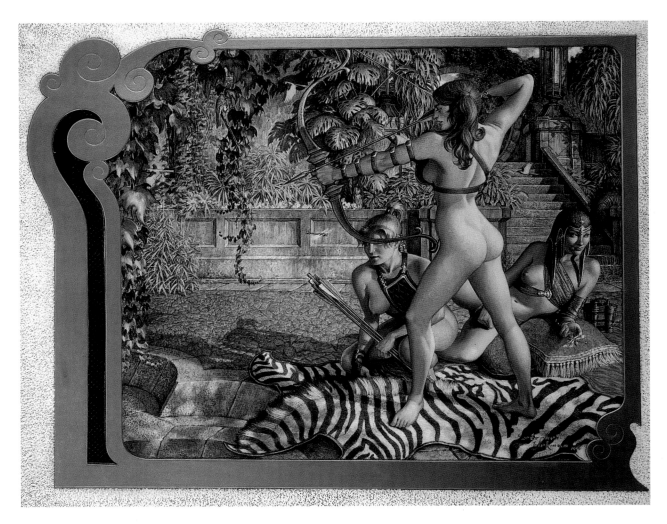

Stephen Hickman: ***The Archers of Lhune***, private commission, 1990.
Oils and mixed media.
24in x 30in (61cm x 76cm).
Reproduced by kind permission of the artist.

In 1996 this painting won a Chesley Award (Association of Science Fiction and Fantasy Artists) for unpublished work in colour. Hickman not only painted but framed the work, incorporating into the final work the snakeskin that frames the painted image.

some… well, absolutely hilarious. All of it is novel and entertaining. While novelty alone does not confer value or greatness, in our bedroom and bathroom we find it very pleasing to maintain a high degree of novelty and emotional quotient in the subject matter. The idea is to get a psychological charge out of what we see when we walk into the room. Many visitors probably conclude that our choices of art to keep in the 'private' rooms were compelled by the need to observe the conventional rules of propriety in the more public display spaces. But, frankly, our selections were dictated more by our feeling that these particular artworks just 'belong' here. At least for now. Next year we might feel like moving all the nudes to the Kitchen. Who knows?

The most outrageous pieces are probably H.R. Giger's *Biomechanoid II*, a marvellous, luminous work that changes intensity with the lighting, and Les Edwards's *Vampire Lover I* (not shown), one of a pair of privately commissioned paintings that portrays a traditional male vampire preparing to ravish an unsuspecting nude female victim. This painting currently occupies a space above our bed, but it will soon move to make room for its mate, which depicts the concept in reverse – a female vampire ravishing a male victim.

Indeed, several of the pieces in the room are private commissions, or are personal works that have never been published owing

to their subject matter. Among these are Steve Hickman's award-winning *The Archers of Lhune*, for which Hickman personally took charge of constructing the custom framing, including purchase of the decorative snakeskin used in the design. Also displayed are John Berkey's nude *Portrait of a Dark-Haired Woman* (not shown) and Clyde Caldwell's *Frank Family Portrait*.

This special painting, which Howard commissioned as a surprise holiday gift to the family for Christmas 1978, has always been a source of amusement to us and – shall we say – bemusement to our children. Caldwell was then, and still is today, famous for his strong, imaginative and sexy Sword & Sorcery characters. Howard thought it would be great fun to have Clyde depict the Franks as a barbarian, his babe and his brood. This was our first foray into the world of commissioning fantasy portraits of ourselves, and the results forced us to a family vote. Our children felt strongly that the proprieties must be observed, with veiling and armour discretely camouflaging body parts, especially on the ladies. Howard adamantly refused to accept window-dressing, and was allowed to remain a bare-chested barbarian, true to the original version sketched by the artist. Now that they are grown, our children enjoy seeing the painting when they visit, and reminisce over the loss of our pet dragon/collie Flash (disguised well in the portrait).

Other works of fantasy portraiture also hang in bedroom area, such as Jael's *Portrait of Howard and Jane* and J.K. Potter's *Portrait of Jane* (not shown). Also to be found are two (originally) nineteenth-century dog portraits (not shown) which have been refashioned by the contemporary artist Thierry Poncelet. Jane chose these for the spot above her dresser, where she can see them every

Above
Jael: **Portrait of Howard and Jane**, private commission, 1991.
Oils.
32in x 24in (81cm x 61cm).
Reproduced by kind permission of the artist.

Above left
Clyde Caldwell: **Frank Family Portrait**, private commission, 1978.
Oils.
30in x 24in (76cm x 61cm).
Reproduced by kind permission of the artist.

Richard Powers: ***Mars Cityscape***,
personal work, 1987.
Acrylics.
32in x 60in (81cm x 152cm).
Reproduced by kind permission of
Richard Gid Powers.

morning. These were not commissioned portraits, but everyone agrees: they are darn good likenesses of Howard and Jane.

A wonderful three-dimensional fantasy here is Lorraine Vail's large sculpture *Pet* (see page 63). When the wall-to-wall curtains are drawn and the ceiling track lights illuminate the bronze, the piece looks austere, as if in a gallery-like setting. But when the curtains are open and the light shines through the glass windows, the sunlight bounces off the polished bronze and the work glistens with life and warmth. From every angle, the viewer is entranced by this cat/woman, with her arched, muscled back and her 'wee pet'.

A major work by the late Richard Powers, *Mars Cityscape*, fills the space between the Giger and the dog portraits. This has always been one of our favourite paintings. It had to be moved twice – 'bumped' from the Kitchen to the Reverence Room – before it found its present home in the bedroom. The concept for this painting came from an earlier 1956 Powers work for Ballantine Books, a cover for Arthur C. Clarke's *Reach for Tomorrow* (1956). This most unusual earlier book-cover painting was the only one Powers ever painted such that the book had to be held sideways for proper viewing. The version we possess, the very large one, was painted in 1986–7 as

Dean Morrissey: ***Sleeperflight***, cover
for a children's book (Abrams) written
and illustrated by Morrissey, 1991.
Oils on canvas.
30in x 40in (76cm x 102cm).
Reproduced by kind permission of the artist.

Richard's homage to the earlier, smaller work. He envisioned this painting as the centrepiece of a five-piece work, but this project was never completed. Later the painting was used as a book cover, then was exhibited for some weeks at the Hayden Planetarium in New York along with a selection of other works. It was during this time that we purchased it, sight unseen, on the basis of a 3in x 5in (7.5cm x 13cm) postcard-sized rendering which Powers had thumb-tacked to his panel display at the 1989 Chicago Worldcon, where he was Artist Guest of Honour. The card was accompanied by a handwritten note saying, 'This is available for purchase' – no size, no price, and no indication that, once the purchase had been made, the buyer would have to wait two months for delivery! Nevertheless we had to have it, and in the process we were thrilled to meet Richard for the first time.

Two fine oil paintings depicting lighter-than-air flight, by Dean Morrissey and Tom Kidd, share wall space, while nearby are two highly erotic paintings by Boris Vallejo (not shown). The juxtaposition of what are clearly 'painterly' paintings – on canvas, and rendered in a classical Brandywine style – with the erotic paintings, which are done in almost photographic style, creates a refreshing and delightful contrast.

The Master Bedroom Suite is composed of a big bedroom, two large walk-in closets and a painting-lined hallway connecting separate very large bath- and WC rooms. In our house, where there are rooms there is art, and these rooms are no exception. The closets are lined with shelves and paintings, the hallway holds the family portraits and other more startling gems, the WC room is our naked-

Thomas Kidd (painting as Gnemo): ***Port Rockwell***, personal work, 1993.
Oils.
30in x 22in (76cm x 56cm).
Reproduced by kind permission of the artist.

One in a series of works for a planned book, *Gnemo*, on airships, adventure and exploration.

sexy-lady room (we keep this door closed on most tours), and the bathroom (which we don't use for baths) is the current home of a series of six *Tarzan* paintings by Barclay Shaw; we plan to move the *Tarzan* paintings to our new guest bedroom suite when that space – to be known as The Veldt in honour of the 1950 Ray Bradbury story – is completed.

That means we will have an entire long blank wall for more bedroom art.

We can hardly wait!

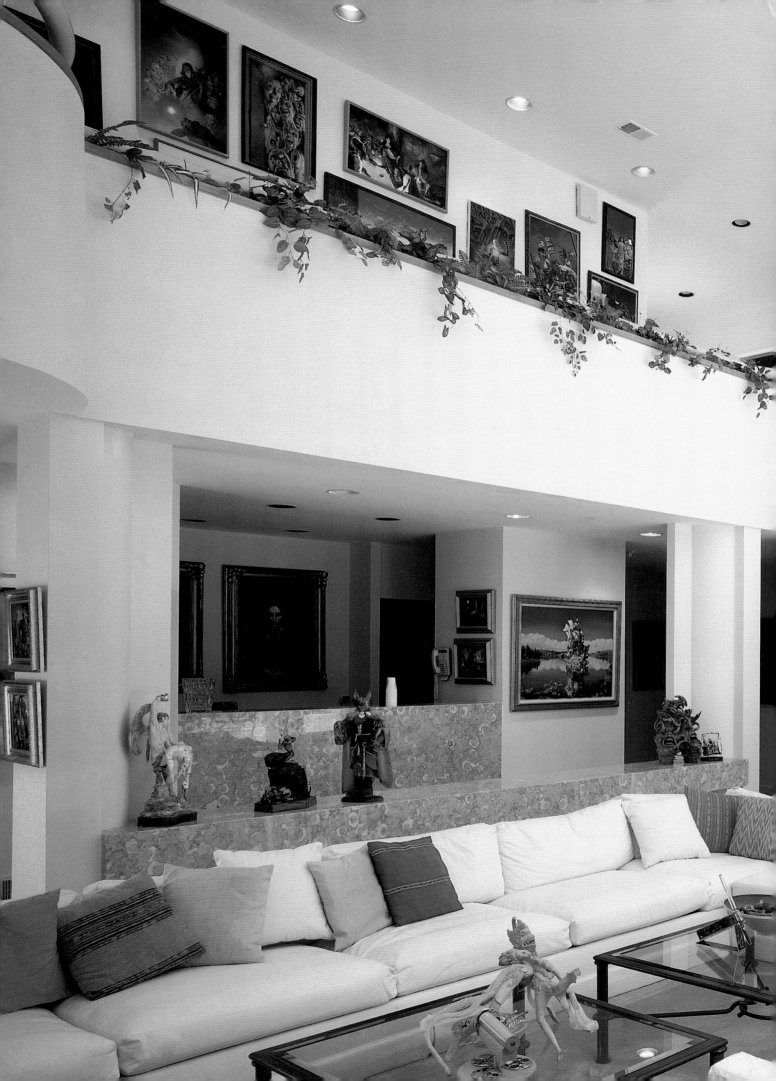

LOWER LEVEL

CHAPTER 9

LIVING ROOM AND
PROMENADE GALLERY

STANDING at the top of the Grand Staircase leading to the living room, the visitor is presented with a dramatic scene. The rear wall of the house is a two-storey expanse of glass, so the vista as you descend the Grand Staircase is not just of an immense open area within the house but also of the terrace beyond the Living Room as well as of the promenade of sculptures appearing at intervals along the interior wall of glass panels.

The main interior space is a theatrical bit of architectural wizardry, built to accommodate the grand gesture and hence perfectly suited to the often dramatic and intense nature of science-fiction and fantasy art. It's definitely not suited to the display of eighteenth-century miniatures or Georgian silver! And it's even more definitely not a cosy nest filled with dark corners and comfortable hiding places. In fact some visitors, gazing out into the home proper from the top of the stairs, have likened the experience to that of walking into an aircraft hangar or the main hall of a museum. (To give an idea of the proportions involved: standing in the Living Room, you need a 22ft/6.7m ladder to change the light bulbs in the ceiling.)

Only when you reach the foot of the stairs can you see the paintings displayed along the interior wall of this open Living Room, among them Richard Powers's major works for Robert A. Heinlein's *The Number of the Beast*.

In the collection are the paintings for the mass-market paperback and the trade paperback editions of this book, both issued by Fawcett in 1980. Our negotiations with Richard to obtain these paintings took years. First off, he refused to sell us the cover for the trade edition on its own because he felt it was part of the much larger portfolio of work that included not only this but also the fifty-four black-and-white interior illustrations and the colour art for the mass-market paperback; it was his belief that a major Texas university was seriously interested in the entire portfolio as an addition to its extensive collection of Heinlein-related material. That deal fell through.

Then Richard said he would sell us the cover painting but only if we bought the entire portfolio – and at an astronomical price. Eventually he brought the price down a bit and we weakened and agreed to purchase the lot. But now he refused to sell because he had misplaced one of the small interior illustrations and wouldn't 'feel right' if he sold the portfolio with this minor omission.

Finally, one day – driven no doubt by the need to pay plumbing and car-repair bills – he agreed that he would sell us the incomplete

H.R. Giger: ***Female Torso***, personal work, 1994.
Painted aluminium and cast bronze.
41in x 17 in x 14 in (104cm x 44cm x 35cm).
Copyright © 1999 H.R. Giger (Fine Art).
Reproduced by permission.

Facing page
Richard Powers: ***The Number of the Beast***, cover for the mass-market paperback edition (Fawcett) of the novel by Robert A. Heinlein, 1980.
Oils.
30in x 20in (76cm x 51cm).
Reproduced by kind permission of Richard Gid Powers.

Richard Powers: **The Number of the Beast**, cover for the trade paperback edition (Fawcett) of the novel by Robert A. Heinlein, 1980.
Oils.
36in x 60in (91cm x 152cm).
Reproduced by kind permission of Richard Gid Powers.

Opposite
Tom Barber: **Attack at Dawn**, personal work c.1980.
Oils on canvas.
24in x 36in (61cm x 91cm).
Reproduced by arrangement with the Frank Collection.

portfolio: the two cover paintings and fifty-three of the original fifty-four interiors. So we drove to Connecticut to pick up the treasure. When we arrived, Richard, looking rather sheepish, told us that he had changed his mind. Our hearts sank – but only for a moment, because then he explained that what he really wanted to do was keep the set of interior illustrations. So all we would have to buy on top of the trade cover was the mass-market cover. We quickly agreed to a new price for the deal, sans interiors.

Then he showed us the mass-market cover. It was stunning, as you can see. Immediately we told Richard that we couldn't possibly pay him the sum he'd asked for. We gave him long enough for that to sink in and then added that the deal was worth more than we'd just agreed – what we'd meant was that we were going to pay him extra.

Richard's doubletake was the best we've ever seen.

Along the outer perimeter, backed by the glass wall, can be found some major sculptural works, among them *Female Torso*, a lifesize work in cast and painted aluminium and bronze by H.R. Giger. While this was not the first acquisition which required us to discover the finer points of importing artworks from overseas, it was a new experience in terms of learning how to assemble, and properly display, a very 'top-heavy' metal statue. The work arrived in two pieces: the sculpture, and a slim metal 6ft (1.8m) pole which was its central support and stand. We needed two large men to hoist the statue into the air, after which we spent a while nervously watching it as it swayed in precarious balance next to a wall of glass! Shortly

thereafter we decided to let our metal lady nap on the floor until a special pedestal support could be constructed.

Within feet of the torso stands Gary Persello's *Reflection*, another sculptural balancing act. Much of the beauty of the statue rests (no pun intended) on the fact that the barbarian warrior's hand is the sole support for 150 pounds (82kg) of bronze. It is a casting marvel that impresses everyone who sees this beautiful, lifelike sculpture.

Three further major three-dimensional works can be found along the glassed promenade, all of them by Lisa Snellings (see page 106). These are part of a significant ongoing project which Lisa initiated in 1994, and which will comprise – when completed – various 'rides' and entertainments to be found in a dark carnival. Each year we have been commissioning one piece for the carnival, leaving the decision as to the implementation and subject matter to the artist. (We have often taken this route, in our private commissions, leaving artists free to follow their inspiration – and we have never been disappointed by the results.)

This year she has been working on a piece featuring a hootchy-kootch dancer, *Aunt Ida's Nest Near Midnight* (not shown), and Lisa speaks about the fortune-teller and performers in the sideshow… in our future. There's no telling at this point what they might be like. Each work in the series is a richly detailed kinetic sculpture that features fantasy characters and animals; the sorts of mysterious and grotesque figures that might inhabit a Gothic fantasy circus. Sometimes moody, sometimes clever, but always provocative, her figures seem to echo what is scary – but also funny and odd – about our own dreams.

Watching over these sculptures, peering warily above the tops of their shields, is Tom Barber's small company of armoured warriors

Gary Persello: ***Reflection***, personal work, #4 of 15, 1992.
Hand cast and patinated bronze.
48in x 26in x 32in (122cm x 66cm x 81cm).
Reproduced by kind permission of the artist.

Award-winning sculpture displayed at the exhibition *Pavilions of Wonder: The Art of Fantasy and Science Fiction*, put on by the Canton Museum of Art, Canton, Ohio, 1996.

Tim White: ***The Krugg Syndrome***,
cover for the novel (Grafton, paperback,
1988) by Angus McAllister, 1987.
Acrylics.
12in x 16in (30cm x 41cm).
Reproduced by kind permission of the artist.

in *Attack at Dawn*, a personal work he created *c.*1980. This is the first piece we purchased from him. We were immediately drawn to the image, always wondering: who and what army might those soldiers be confronting that morning? We lost track of Tom in the early 1980s when he moved out West to paint Western scenes, and no one that we know in the fantasy-art world has ever run into him again. That's a shame, because Barber was a great talent and, if he had stayed in the field, he would today be known to fans around the world.

A recent addition to our collection is Tim White's painting for Angus McAllister's 1988 novel *The Krugg Syndrome*. A relatively small work, this beautifully coloured landscape evokes all that is fanciful and imaginative. We think a lot of Tim's work. Unfortunately so does Tim, so he hates to part with any. The negotiation for the purchase of this picture actually began years ago, and it was not until this year that the transaction was completed. We count ourselves lucky to be among the privileged few who own a Tim White painting.

CHAPTER 10
THE SWORD & SORCERY
GUEST ROOM

W̶E HAVE several tests for visitors who look as if they might become friends. The first is to watch their general reaction to the collection when they enter the front door. Do they think that *Spot* (see page 25) is cute, or do they go 'ugh!' under their breath? Is it 'oohs' and 'aahs', or is it 'eeks' and even less pleasant mutterings?

A second, more demanding, test is how they react upon meeting *Mom*, as we affectionately call a latex-moulded body suit (not shown) we own that was worn in the 1983 horror movie *Mausoleum*. By anybody's standards, *Mom* is really ugly – among other things, her breasts sport tiny teeth instead of nipples – so that unexpectedly stumbling upon her in the dark is not a formula for increasing your lifespan! We acquired *Mom* at the 1987 Ackerman auction and she has sat in various chairs around the house ever since.

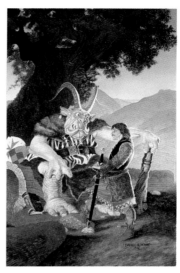

Above
Daniel Horne: ***The Incorporated Knight***, cover for the novel (Baen, paperback) by L. Sprague and Catherine de Camp, 1988.
Oils.
30in x 18in (76cm x 46cm).
Reproduced by kind permission of the artist.

Left
Larry Elmore: ***Good Catch***, TSR™ Advanced Gaming Manual, 1989.
Oils.
30in x 24in (76cm x 61cm).
Copyright © by TSR™, Inc., reproduced by permission.

Carl Lundgren: ***Take the A Train***,
personal work, *c.*1976.
Oils.
28in x 20in (71cm x 51cm).
Reproduced by kind permission of the artist.

This painting won the Society of
Illustrators Annual Show, 1979, and the
Delaware Art Museum Invitational
Exhibit of the National Academy of
Fantastic Art in 1976. It was also used
as the cover for the anthology *The Year's
Finest Fantasy* (1978) edited by Terry
Carr.

Clyde Caldwell: ***The Second Season
of the Witch***, page for the *Heavy
Metal* calendar, *c.*1977/8.
Mixed media (airbrush using Dr Martin's
dyes, gouache 'and probably a little
Prisma Color coloured pencil').
30in x 24in (76cm x 61cm).
Reproduced by kind permission of the artist.

The third and ultimate qualifier for a would-be friend is his or her
ability to get a good night's sleep in our Guest Room. We didn't plan
it that way. We didn't overload the room with horror or blood-and-
guts art. In fact, many of the paintings in the room, like Carl
Lundgren's *Take the A Train* or Daniel Horne's *The Incorporated
Knight*, seem to our eyes to be quite charming examples of fantasy
art. After all, what could be frightening about a friendly dragon
overlooking a modern, graffiti-covered train or a friendly critter and
his supplicant knight?

We think that Larry Elmore's *Good Catch* is downright funny.
We've seen similar scenes in photos (and, courtesy of taxidermists,
in actuality) offered by friends as examples of the 'ones that didn't
get away'. And as for *The Second Season of the Witch* by Clyde
Caldwell – showing a gorgeous sword-wielding female dressed for
action – who could, in these liberal modern times, speak ill of such
a strong, saucy, character? Incidentally, this painting was one of our

earliest purchases from Clyde and, while he has gone on to paint many further finely wrought ladies, this remains among our favourites.

But other paintings – such as Gerald Brom's *The Amber Enchantress*, Jeff Easley's *Wilderness Survival Guide* and Keith Parkinson's *Castle Greyhawk* (see page 80) – seem to have unsettling effects on the uninitiated. Our guests report that the overall impression of the room is, shall we say, arduous. This feeling is not helped by such images (not shown) as a haunted woman suspended over a volcanic landscape (a Ron Walotsky cover for Tor's 1988 edition of Robert Silverberg's *Born With the Dead*), a winged devil-like monster with a huge mouth full of teeth ripping the top off a bus loaded with passengers (Jeff Easley's *13th and Vine*, 1986, done as an interior for *Amazing*), and rugged warrior cats (not shown) painted by Steve Hickman for the covers of the first four titles in the *Man–Kzin Wars* book series created by Larry Niven.

We like having company and guests and make special efforts to make them comfortable. We provide maps of the contents of the refrigerators and leave lights on all night so they can find their way around the house. Indeed, we are in the process of planning a second guest room that will become The Veldt, in which we intend to concentrate much of our jungle-themed art, both real and fantastical, including masks, throwing spears and bows and arrows. Though we've given a lot of consideration to the individual items of its decor – and have been amassing these from our trips to South

Gerald Brom: ***The Amber Enchantress***, cover for Prism Pentad (Book 3 of the *Dark Sun* series, TSR™, paperback) by Troy Denning, 1992. Oils.
30in x 40in (76cm x 102cm).
Copyright © by TSR™, Inc., reproduced by permission.

Jeff Easley: ***Wilderness Survival Guide***, TSR™ gaming manual cover, 1985. Oils.
17½in x 14in (44cm x 36cm).
Copyright © by TSR™, Inc., reproduced by permission.

Keith Parkinson: **Castle Greyhawk**.
Advanced Dungeons & Dragons™ game
cover module, 1987.
Acrylics.
24in x 18in (61cm x 46cm).
*Copyright © by TSR™, Inc., reproduced by
permission.*

America and New Guinea as well as from auction houses – we
haven't yet thought too much about the ultimate effect on our guests
– will anyone actually be able to sleep in this room?

We certainly hope so – but we suspect that the degree of rest-
fulness of their stay will determine whether or not they come back
for more.

CHAPTER 11

KNIGHT'S ANTEROOM
AND MASTER LIBRARY

LIBRARIES are like works of art – you can never have enough of them. We already have three libraries in the house, and a fourth will soon be joining them. The Master Library (which came with the house when we bought it) holds much of our collection of books published before the 1950s as well as our hundreds of illustrated volumes of art reference books. You can reach it *via* either the Grand Staircase or the Pulp Hall and Stairwell. If you take this latter path, you are in for a special experience.

The Stairwell empties into a relatively small, sheltered anteroom. At the bottom of the stairs are four paintings (three not shown): one is by Jeff Jones, two are by Roy Krenkel, and then there's the fourth. This is a small painting of an American Indian battling a cowboy. Although not fantasy or science fiction, this Western painting seems to fit right in. The explanation is obvious if you examine the signature – the artist is Frank Frazetta, one of the giants of the world of fantasy art.

Three steps past this Frazetta, and right around the corner from Krenkel's *Hadon of Ancient Opar* (see page 44), and you are in the Anteroom. The experience can be breathtaking.

In front of you is a large, marvellous oil painting by Frazetta called *Fire and Ice* (see page 85). To your right is a contemporary recreation of a sixteenth-century Spanish full suit of armour which we have dubbed 'Don Francisco' in honour of Howard's chivalric

Boris Vallejo: **Ram**, from his collection *Mirage* (Paper Tiger, paperback), 1979. Oils.
28in x 19in (71cm x 48cm).
Reproduced by kind permission of the artist.

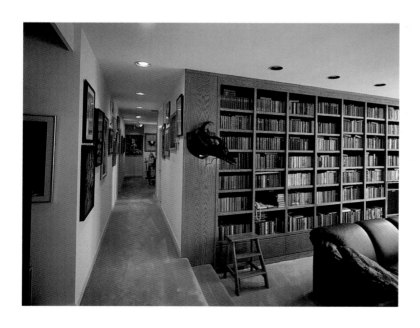

Knight's Anteroom and Master Library.

Frank Frazetta: ***Flashing Swords #1***, cover for the anthology (Dell, paperback) edited by Lin Carter, 1973. Oils.
23in x 19in (58cm x 48cm).
Reproduced by kind permission of the artist.

According to the Guernseys catalogue description, this is one of the largest Frazettas ever created, and one of the top Frazetta paintings in private hands. In any event, it certainly pleases us! This may have been originally painted for Lancer's *Conan* series in the late 1960s and not used there, since two Conan figures on Lancer covers are very similar to *Barbarian No. 100* in Ballantine's *Frazetta No. 3*.

instincts. To its right is *Demon Lover*, by Boris Vallejo, the lead painting in Boris's 1982 book of erotic fantasy art, *Mirage*. Behind you is a further great Frazetta oil painting, this one of a Conan-like warrior seen in the early 1970s on a Dell paperback anthology edited by Lin Carter, *Flashing Swords! #1* (1973). And nearby is another Boris painting that blends the sensual and erotic with the fantastic. This painting, *Ram*, also appeared in *Mirage*, and again represents Boris at his best.

We acquired the Frazetta paintings several years ago after years of searching — both literal (because of the marketplace scarcity of such artworks) and soul (because of the cost). It's easy to appreciate Frazetta's talent through his many cover illustrations, art books and prints. But it was only after our trip to East Stroudsberg,

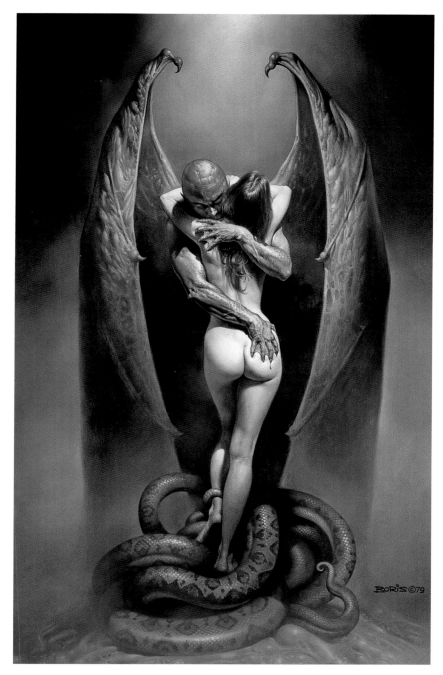

Boris Vallejo: **Demon Lover**,
from his collection *Mirage*
(Paper Tiger, paperback), 1979.
Oils.
28½in x 19½in (72cm x 50cm).
*Reproduced by kind permission
of the artist.*

Pennsylvania, to visit the private museum managed by his wife Ellie that we concluded that no significant collection of fantasy art could be complete without a Frazetta. In East Stroudsberg, surrounded by dozens of his magnificent paintings, the immensity of his genius was nearly overwhelming. We left that afternoon determined that one day we would be able to hang one of his great works on our walls.

Our first effort, in 1992, to acquire a Frazetta failed: we were beaten out by a then-unknown telephone bidder at a Christies auction. We later learned that the bidder in question was actually a well-known rock star, and there was probably no way we could have afforded to win that contest. Less than twelve months later, however, at a Guernseys auction, we were successful, and the barbarian with his ball and chain was ours.

Don Maitz: ***The Sword of the
Lictor***, cover for the novel (Pocket,
hardback and paperback) by Gene
Wolfe, Volume 3 of Wolfe's *The Book
of the New Sun*, 1982.
Oils.
30in x 20in (76cm x 51cm).
Reproduced by kind permission of the artist.

Facing page
Frank Frazetta: ***Fire and Ice***,
poster and cover for the animated
movie *Fire and Ice*, produced by
Frazetta and Ralph Bakshi, 1982.
Oils on canvas.
36in x 24in (91cm x 61cm).
Reproduced by kind permission of the artist.

Part of the fun of collecting is the excitement of the hunt, the
emotions of the contest, the thrill at the moment of victory and
the warmth of its afterglow. For all of these reasons – in addi-
tion, of course, to its immense artistic merit – this Frazetta is
one of our favourite paintings and will probably ever remain
so, no matter what other paintings join the collection.

We've already written (see page 14) of the 1987 Ackerman
auction which brought eighteen paintings to the collection.
Both of the Boris paintings in the Anteroom were among this
hoard. We believe that *Demon Lover* is one of Boris's finest
fantasy paintings. The picture radiates power, sensuality and
tenderness all at once. The demon enfolds his love in leath-
ery wings, drawing a single rivulet of blood with his gentle
touch. In that trickle of blood are the dreams of a million
fantasy worlds.

The 1987 Ackerman auction was also the first time we
had ever seen any material group of Frazetta originals.
Among the group was *Fire and Ice*, Frazetta's promotional
painting for the 1982 Ralph Bakshi-directed,
Frazetta/Bakshi-produced animated movie of the same
name. It was among the two Frazetta paintings that we
decided to pursue, hoping that, if it had to be one or the
other, *Fire* would be the one we'd acquire. Unfortunately on
that day it was not to be: most of the Frazettas were with-
drawn from the auction for failing to meet their reserve
prices. We saw *Fire* again when we visited the Frazetta
Museum – this time with neither hope nor expectation that
it would ever be in our collection. But then, several years ago, we
were unexpectedly given the chance to acquire, directly from the
Frazettas, a single major Frazetta painting. *Fire* was our choice, and
today it hangs in its special place of honour. We are very grateful to
the Frazettas for giving us permission to reproduce the painting in
this book so that we can share our enjoyment of it with you.

You pass from the Anteroom into the Master Library through
an open entryway. An unbroken row of bookcases and books is the
first view. A long (3ft/90cm), graceful, mounted dragon's head, *Sean*
(not shown), created by Mary Marquis, is the second. We came upon
this trophy at the 1997 World Science Fiction Convention. Made of
fine kidskin leather, with glass eyes and sharp teeth, it cried out to
join the Frank family menagerie. The Master Library, where
numerous other dragons can be found in illustration and text, was a
natural location.

This Library also serves as our movie theatre, where we
entertain guests with laserdisk and DVD science-fiction and fantasy
movies. Two Don Maitz paintings, *The Sword of the Lictor* and *Fane*
(not shown), flank a large projection television set. *Sword* is the
cover for the third volume (1982) of Gene Wolfe's well known series
The Book of the New Sun. It is a provocative painting of a strange
warrior confronted by an evil giant leering fiendishly at both the
warrior and the viewer. Nearby is Gary Ruddell's cover for Al
Sarrantonio's *Campbell Wood* (see page 86). Here another face
confronts the viewer, but this one – trapped in, and part of, a

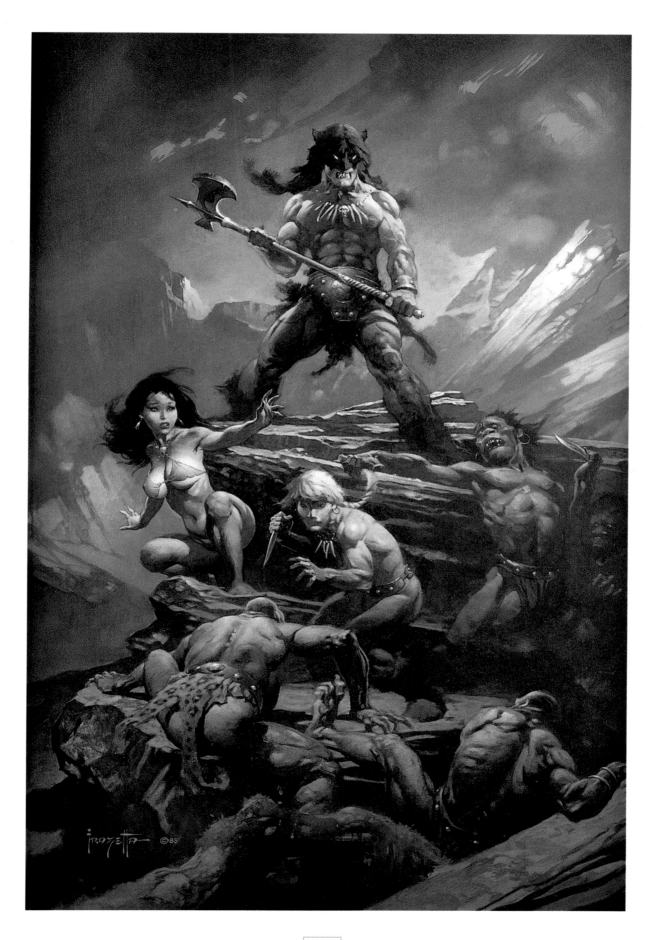

Gary Ruddell: ***Campbell Wood***,
cover for the novel (Berkley, paperback)
by Al Sarrantonio, 1987.
Oils on canvas.
19in x 14½in (48cm x 37cm).
Reproduced by kind permission of the artist.

sinister forest – displays not evil but sheer terror. This look is entire-
ly appropriate considering the artworks that lurk around the corner,
down the Hall of Horror.

Sharing the Master Library walls, but not shown here, are also a
painting by Romas (real name Romas Kukalis), two by Rick Berry,
and a lovely painting of fairies and forest creatures by Rowena. The
rear of the Library looks out over Lisa Snellings's *Short Trip to
October*, a nicely Gothic and fully operational 6ft x 4ft (1.8m x 1.2m)
rollercoaster (not shown), and on to the woods of the nature
preserve. The transition between the Master Library and the Hall is
marked by Jim Warren's *Weaveworld* (see opposite), the cover of
Clive Barker's well known 1987 novel.

CHAPTER 12

THE HALL OF HORROR

IDEAS sometimes just evolve out of casual remarks. The Hall of Horror is a good example. Since we've no desire to be branded by our neighbours or delivery persons as devil worshippers, disciples of the Marquis de Sade or just plain nuts, we keep our most extreme pieces out of mainstream pathways. While a plumber needing to fix a downstairs bathroom might find himself face-to-face with a more 'radical' piece, the guy delivering the pizza would never be exposed to such stuff. Over time… well, on the principle that vampires of a feather flock together, horror art just seemed to gravitate to the hallway between the Master Library and Howard's Office.

The hall's name came about when a visitor, viewing our Jim Warren painting for the cover of Clive Barker's novel *Weaveworld* and then immediately afterwards one of Les Edwards's 'splatter'

Alan M. Clark: ***Half Scairt***,
personal work, special commission,
1988.
Acrylics.
35in x 23½in (89cm x 60cm).
Reproduced by kind permission of the artist.

This painting subsequently won the
Lunacon 1989 (Science Fiction
Convention) Judges' Choice Award for
'Horror Best in Show'.

Left
Jim Warren: ***Weaveworld***, part of
cover design and inside first full-colour
page for the novel (Pocket, paperback)
by Clive Barker, 1988.
Oils on canvas.
28in x 22in (71cm x 56cm).
Reproduced by kind permission of the artist.

favourites, the cover for Guy N. Smith's 1988 novel *Cannibals* (not shown), exclaimed: 'Oh, it's a hall of horrors!' The name stuck with us, and helped define future additions to the hall. Out went the pretty stuff. In came the blood and gore and yucky creatures and demons from Hell (and other nasty places). Today all the paintings here are of the horror genre; when we contemplate purchasing a new piece of horror art, the big question is: 'How will it look (and will there be room) in the hall?'

Toward the end of the hall you'll find, in a row, the first four of Bob Eggleton's paintings for Brian Lumley's *Necroscope* series of novels. We reproduce here the first and third of the series, *Necroscope* and *The Source*, to give you the general idea. For a while, Bob thought that we collected only skulls, and – once we had purchased the first four – continued for the next few years to offer us every vampire skull he created, although we suspect he also thought us a bit strange for the interest: he seemed to be relieved when he finally visited the Collection and found there was lots of more 'normal' art to balance his and other artists' horror creations.

Facing Eggleton's vampiric skulls is a diptych by Michael Whelan, *The Lovecraft Mythos*. Created in 1982 to illustrate a seven-volume Ballantine/Del Rey edition (1980–85) of the works of H.P. Lovecraft and an anthology, *The Best of H.P. Lovecraft: Bloodcurdling Tales of Horror and the Macabre* (1982), these two paintings are among our most thrilling acquisitions. The pair fit together so seamlessly that either of them can be on the left or on the right and they still form together a continuous view of Lovecraft's weird realm. The interpretations of the images of Lovecraft's world are truly horrific, and demonstrate why Whelan is regarded as one of the world's greatest science-fiction and fantasy illustrators.

Below and facing page
Michael Whelan: **Lovecraft Mythos Diptych**, painting in two parts, *c.*1980. Acrylics.
Each part 28in x 17in (71cm x 43cm).
Reproduced by kind permission of the artist.

This painting was used on the covers of seven paperback books (Ballantine/Del Rey 1980–85) collecting the works of H.P. Lovecraft. The individual titles are: *The Best of H.P. Lovecraft: Bloodcurdling Tales of Horror and the Macabre, The Tomb and Other Tales, The Dream-Quest of Unknown Kadath, The Case of Charles Dexter Ward, At the Mountains of Madness and Other Tales of Terror, The Lurking Fear and Other Stories* and *The Doom that Came to Sarnath and Other Stories.*

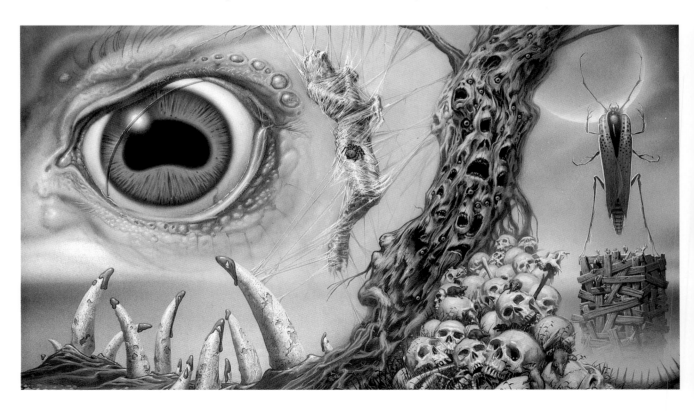

Far left
Bob Eggleton: **Necroscope I**, cover
for the first novel (Tor, paperback) in
the series by Brian Lumley, 1989.
Acrylics.
24in x 14in (61cm x 36cm).
Reproduced by kind permission of the artist.

The actual cover of the paperback is
embossed, and this somewhat detracts
from the horror of the printed image.

Left
Bob Eggleton: **Necroscope III:
The Source**, cover for the third novel
(Tor, paperback) in the series by Brian
Lumley, 1989.
Acrylics.
20in x 13½in (51cm x 34cm).
Reproduced by kind permission of the artist.

Eggleton somehow was able to sustain
the variety in these images over the
course of Lumley's long and successful
series.

Lovecraft's images are revisited by Raymond Bayless in the cover painting for the 1992 Arkham House reissue of *Dagon and Other Macabre Tales* (see page 90). Bayless's classical painterly style imparts an air of reality to the (hopefully) unreal world of Cthulhu, and to the Elder Gods and creatures that inhabit the Mythos.

The middle of the hallway reveals one of several privately commissioned paintings by Alan M. Clark. The painting titled *Half Scairt* came from an idea that Clark once described to us when we first met him at a science-fiction convention in 1986. Clark, a wonderful artist adept at 'southern rural horror', described the following scene:

Do you know how, when you are walking down a lonely

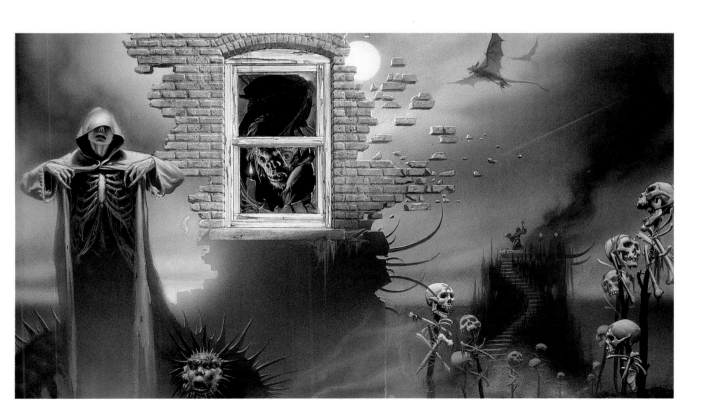

Above
Raymond Bayless: **Dagon and Other Macabre Tales**, 1992.
Oils on canvas.
24in x 18in (61cm x 46cm).

This was done as the cover for the corrected 6th printing in the Arkham House Edition of the collected works of H.P. Lovecraft.
Reproduced by kind permission of the artist.

Right
Denis Beauvais: **Isaac Asimov's Vampire**, cover for the anthology (Ace, paperback) edited by Gardner Dozois and Sheila Williams, 1988.
Acrylics.
24in x 14in (61cm x 36cm).
Reproduced by kind permission of the artist.

Opposite
James Warhola: **A Night in the Lonesome October**, cover for the novel (Avon, paperback) by Roger Zelazny, 1993.
Oils.
36in x 24in (91cm x 61cm).
Reproduced by kind permission of the artist.

country road at sunset, you see things from the corner of your eye that are scary? But when you look directly at them, there's nothing there except maybe a pile of sticks and leaves and some wire. So when you're walking, you're not exactly scared, you're 'half scairt'.

With that thought in our minds, we commissioned Alan to paint *Half Scairt*. This painting won a best-of-show award the next year, and *Half Scairt #2*, *#3*, *#4* and *#5* followed. We own three in the series. Shown here is the original, which illustrates Clark's starkly imaginative treatment of a pastoral landscape.

Horror and horror illustration take many forms, and not all horror has to be outright horrible. Balancing 'purer' visions of caped

J.K. Potter: ***Something Wicked This Way Comes***, cover for one in a series of re-issues (Bantam, paperback) of classic Ray Bradbury stories, 1990.
Hand-tinted photocollage.
15in x 20in (38cm x 51cm).
Reproduced by kind permission of the artist.

Each book in the series featured a cover illustration by a different well-known artist, who was given credit on the cover for his/her contribution – a rarity in sf publishing! We own three in the series, the other two being Barclay Shaw's *Machineries of Joy* (not shown) and Jim Burns's *The Illustrated Man* (see page 19).

bloodsuckers, such as that found in Denis Beauvais's wonderfully detailed cover illustration for *Isaac Asimov's Vampire*, J.K. Potter's cover for *Something Wicked This Way Comes*, for example, captures the spirit of dread evoked in the 1962 Ray Bradbury book by stretching and distorting the otherwise pleasing images of a carnival merry-go-round. Jeff's creative technique, which combines photography with paint, is especially well suited to the horror genre.

In his cover for Roger Zelazny's *A Night in the Lonesome October* (see page 91), James Warhola captures some of the humorous aspects of horror by depicting a fabulous cocktail party attended by guests we might like to meet on a bright and sunny morning – but whom we would certainly go out of our way to avoid after the sun went down.

It's fun to juxtapose such differing views, and it's even more fun to watch the reactions of guests who dare to go down to the end of the Hall of Horror...

CHAPTER 13

HOWARD'S OFFICE

WHEN WE MOVED back out of the city we were determined that our next house would have enough room for all of the books and art we could possibly acquire. As a first step we found a house with enough rooms to hold everything. The second was to identify unneeded bedrooms and other areas that could be converted into galleries and offices. The third was to refine a concept that we had first seen at the home of Forrest Ackerman, where bookcases are fronted by sliding panels on which art can be hung.

Howard's Office is one consequence of these plans. Entered from the Hall of Horror (probably conceived by the original owners as the hallway en route to something like 'the teenager's nook') were once two bedrooms. A construction project undertaken when first we moved in converted these two smaller rooms into a single large one, lined with lush mahogany bookcases that were fronted by sliding panels designed to display art. A mahogany desk and a leather chair and couch add to the serene feeling of the room. This serenity is especially striking, since the only entry for visitors is, as we've said, from the Hall of Horror – which is a place characterized by anything but tranquillity.

Howard's choice of art for his office tends toward the fantastic rather than the sciencefictional. Over his desk hangs a spectacular painting by the Brothers Hildebrandt, *The Fellowship* (see page 94), depicting a band of companions on the outskirts of a fabulous ancient city. Howard likes to demonstrate the effect of lighting on the artists' creation by showing visitors the results of adjusting the intensity of the

Above
Michael Whelan: ***Cuckoo's Egg***,
cover for the novel (Daw, paperback)
by C.J. Cherryh, 1985.
Acrylics.
28in x 18in (71cm x 46cm).
Reproduced by kind permission of the artist.

Before being reproduced on the book
cover this painting had been titled
Hatani by Whelan.

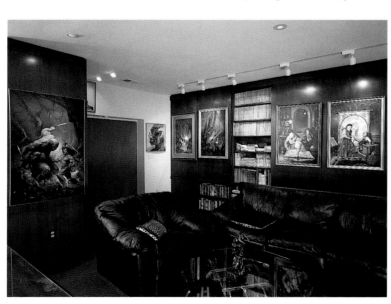

Howard's Office.

Above
Brothers Hildebrandt: **The Fellowship**,
promotional piece done to sell the con-
cept of their fantasy novel *Urshurak*
(1979) as a movie, 1979.
Acrylics on panel, oils.
24in x 48in (61cm x 122cm).
*Reproduced by kind permission of Jean L.
Scrocco, Spiderwebart Gallery, NJ.*

overhead lights. This painting is as vibrant and alive in the dark as
in the light, and the ancient city nearly glows as the lights dim.

Flanking the Hildebrandt are Darrell K. Sweet's *The Slaying
of Glaurun* and Steve Hickman's *A Matter of Vengeance*. Sweet's
painting, created for the 1982 Tolkien calendar, shows a
moustachioed knight striving mightily to withdraw his sword
from the carcase of his successful kill. The Hickman, of two swordsmen
fighting a lion and a leopard, captures many of the elements of great
fantasy art – battling warriors, a well-proportioned heroine and
the golden dome of a magnificent palace. We were honoured when

Right
Darrell K. Sweet: **The Slaying of
Glaurun**, page for a J.R.R. Tolkien
calendar, 1982.
Acrylics.
31½in x 33in (79cm x 84cm).
Reproduced by kind permission of the artist.

Facing page
Stephen Hickman: **A Matter of
Vengeance**, cover for Epic (April
1985).
Oils.
28in x 22in (71cm x 56cm).
Reproduced by kind permission of the artist.

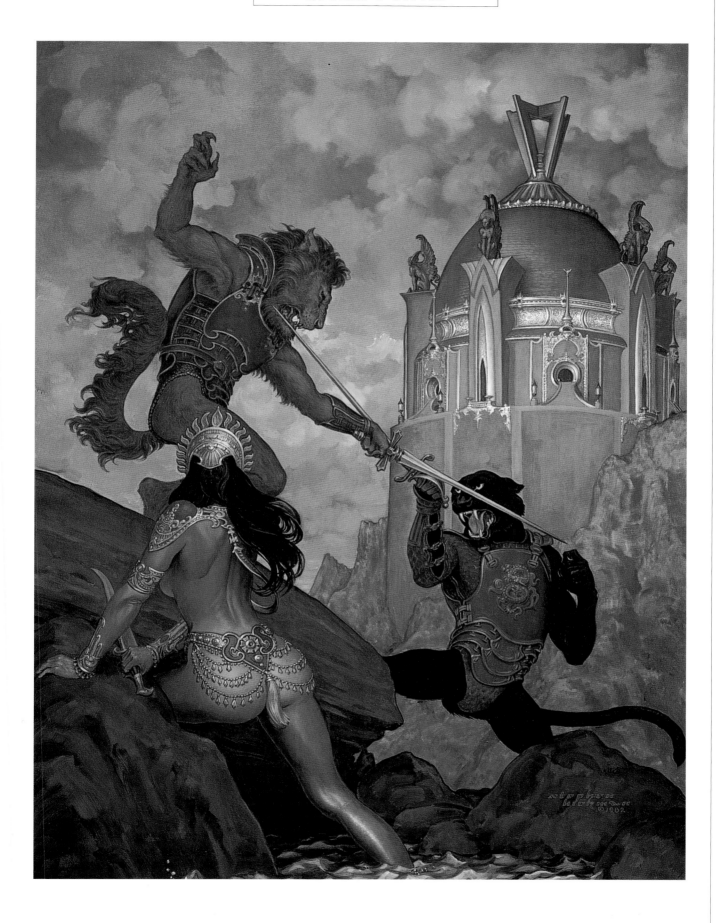

Richard Corben: ***City of Thieves***,
cover for the gamebook (Dell, paperback)
by Ian Livingstone, 1983.
Acrylic and oils.
23½in x 18½in (60cm x 47cm).
Reproduced by kind permission of the artist.

Steve offered this painting to us because it was one he was very fond of, and had vowed not to allow into the 'wrong hands'.

The decor in Howard's Office, as in many other parts of the house, is a study in contrasts: between the ancient and the modern, the mystical and the scientific, the conventional and the mysterious. On a table beneath the Hildebrandt, Sweet and Hickman paintings is a row of computers, monitors and printers. A giant projection television accents one end of the room, yet paintings of ancient evil creatures and opponents in Roman garb or no garb at all are displayed above. In one corner stands a skull-hilted movie prop sword (not shown) from *Erik the Viking* (1989), while directly opposite hang paintings by Ken Kelly, Michael Whelan and Richard Corben. Kelly's painting, for Steve Perry's *Conan the Formidable*, is a modern classic of Sword & Sorcery, with our popular hero in this case having a tough challenge before him – a huge, four-armed enemy whose intentions are clearly evil. Naturally, the prize for victory is a beautiful maiden, painstakingly painted by Kelly to be a woman who would make any battle worthwhile.

Whelan's painting, for C.J. Cherryh's *Cuckoo's Egg*, (see page 93) provides its own set of contrasts. Here, a fur-covered, pointy-eared alien cradles a human child lovingly in his arms. The effect is startling, yet oddly evocative and touching. Whelan has painted every hair and every feature of the alien in finest detail, so that – through realistic portrayal – the creature's life has substance and meaning for the viewer. In contrast, Richard Corben's *City of Thieves* is an amusing piece showing an armour-covered hero and all sorts of weird creatures. Different weirdness, different response. The point of juxtaposing such different images in the same room, while clear to us, is not necessarily clear to others. We've learned to be cautious when trying to explain our motivations, or our reactions to the art, because we've found that our guests often attach such words as 'gross', 'bizarre' and 'weird' to the very same artworks we've labelled 'amusing' or 'funny' or 'hilarious' – or (at the very least) 'entertaining'.

Along one wall of Howard's Office is a row of floor-to-ceiling bookcases. Panels that slide smoothly on built-in tracks are interspersed with open areas. Hanging on each of these panels is a painting. There are two by Dean Morrissey, one by Daniel Horne and several others. One Morrissey painting, for John Morressy's *Kedrigern and the Charming Couple*, is a classic illustration of an ancient seer in flowing white beard and magician's robes. As with so many fantasy paintings in our collection, the published title has little meaning to us – it is needed for identification in our records, but that's about all. It is the image that remains in our memory. The seer, who is consulting a large book of spells, has two companions looking over his shoulders. One, again a white-haired sage, appears intensely interested in the book's contents. The other, the magician's assistant, is a lovely young woman (Dean's wife was the model) standing ready with a further book of spells. In his paintings today, Dean also uses his son as model, continuing this illustrator's tradition of using friends and family for inspiration.

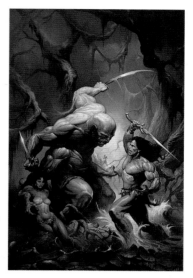

Above
Ken Kelly: **Conan the Formidable**,
cover for the novel (Tor, paperback) by
Steve Perry, 1990.
Oils on masonite.
48in x 31in (122cm x 79cm).
Reproduced by kind permission of the artist.

Left
Dean Morrissey: **Kedrigern and
the Charming Couple**, cover
for the novel (Ace, paperback) by
John Morrissy, 1990.
Oils on canvas.
36in x 24in (91cm x 61cm).

This painting won first place in the
Professional Division at Noreascon 3,
1989, Boston.

Howard's Office, once large and spacious, is now – according
to Howard – barely adequate. One of the goals of our new extension
to the house is to alter this deplorable circumstance. Sometime
soon the office will become a two-storey, four-room
office/library suite with a two-room sliding-panelled library and an
attached conference room. Jane expects that the only conferences
likely to take place are between alien and human opponents, but
Howard is more concerned about the shock he will inevitably suffer
when, for the first time in years, he encounters empty bookshelves
and bare walls!

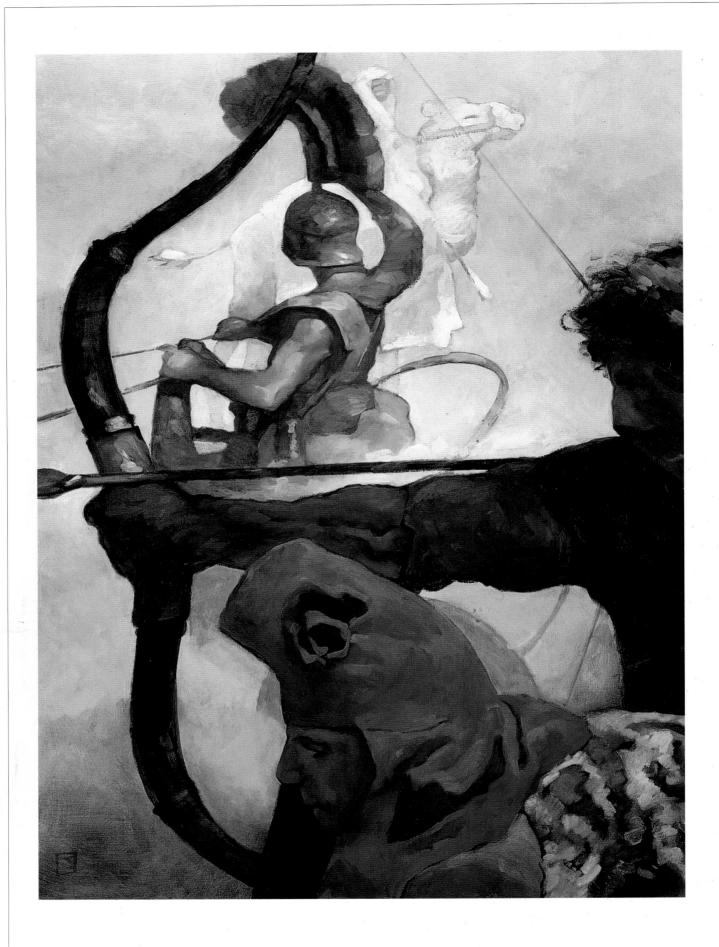

CHAPTER 14

THE HAGGARD ROOM, AFRICA, AND BEYOND

HENRY RIDER HAGGARD'S romances spanned space and time, with remarkable adventures and fantasies set in locales that were exotic for the readers of the late nineteenth century: Africa, Egypt, Rome, Mexico, Israel, Holland, Iceland, Troy, Greece and the Holy Lands. And for adventurous readers today his yarns are no less exciting. With amazing diversity, his narratives crossed the centuries, with stories set in prehistory, in ancient Egypt and the Middle East, amid the Crusades, in the Aztec Empire and in nineteenth-century Africa. Haggard chronicled the rise and fall of the Zulu empire, the collision of the Spanish and Aztec empires, the adventures of Odysseus after his return from Troy, the fall of Jerusalem, and the wanderings of noble heroes in many lands. His works have been published in dozens of languages and translated into films, stage plays and the opera. Some have been continuously in print for over a century. They were illustrated in books and magazines by leading illustrators of the nineteenth and early twentieth centuries such as Charles Kerr, Maurice Greiffenhagen, Lancelot Speed, E.N. Johnson and John Weguelin. Few of the originals of these illustrations survive – which explains why we treasure the Weguelin series of watercolours done for Haggard's *Montezuma's Daughter* (see page 31–2).

As a youth Haggard was an adventurer. He helped raise the Union Jack over Pretoria when Britain annexed the Transvaal

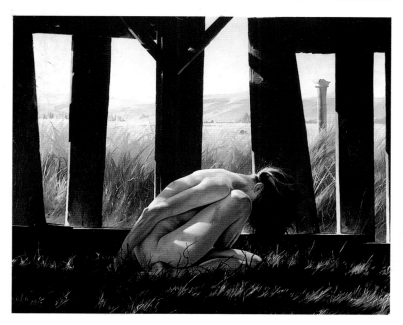

Facing page
Jeff Jones: ***The World's Desire***, private commission done to illustrate the 1890 novel by Haggard and Andrew Lang, 1998.
Oils on canvas.
32in x 24in (81cm x 61cm).
Reproduced by kind permission of the artist.

Left
Gary Ruddell: ***Pearl-Maiden***, private commission done to illustrate the 1903 Haggard novel, 1998.
Oils on canvas mounted on wood panel.
40in x 48in (102cm x 122cm).
Reproduced by kind permission of the artist.

Overleaf
Don Maitz: ***King Solomon's Mines***, private commission done to illustrate the 1885 Haggard novel, 1998.
Acrylics.
30in x 40in (76cm x 102cm).
Reproduced by kind permission of the artist.

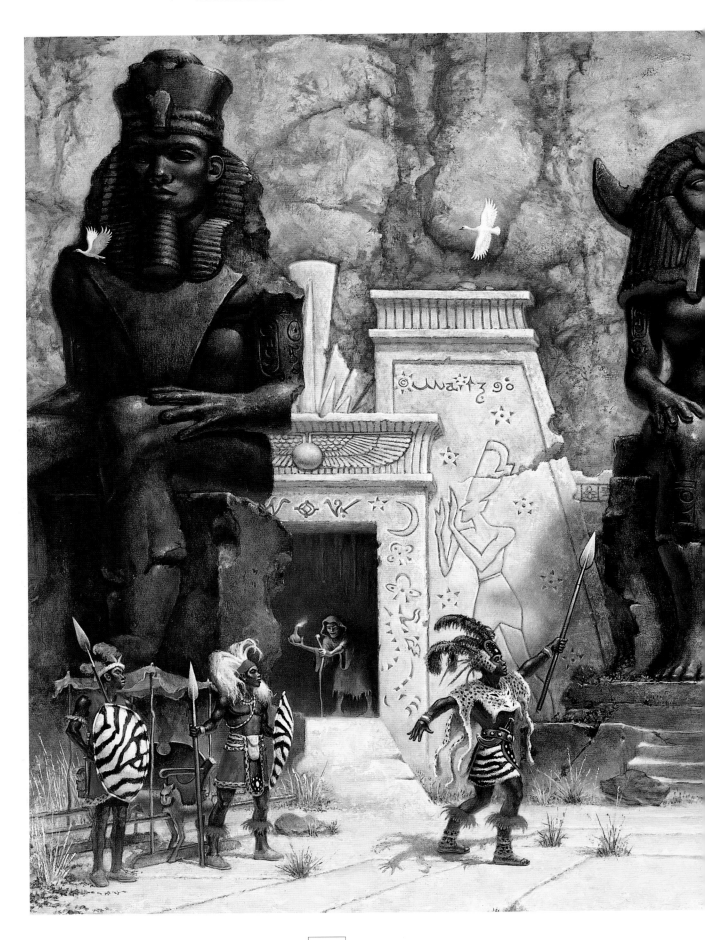

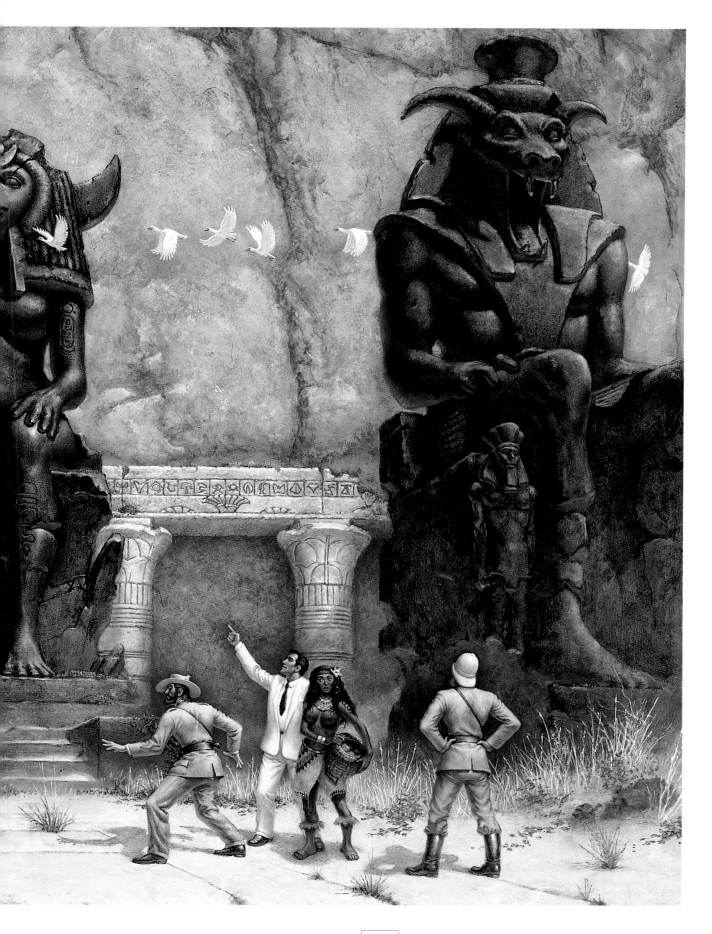

Republic in 1877. Later he was a lawyer, a social reformer, an agricultural revolutionary and a public servant concerned with subjects as varied as soil erosion, the settlement of the poor and the state of the dominions. At age twenty-nine Haggard wrote *King Solomon's Mines* (1885) in his spare time in just six weeks. Two years later he wrote the novel version of *She* (1887). By the time of his death he had written forty-two fantasy and adventure romances, twelve novels and ten works of nonfiction.

Knighted in 1912 for his service to Britain, Haggard made contributions to fantasy literature that have assured him a permanent place in history. Many of today's fantasy and science-fiction authors point to Haggard as an important early influence. In his *Anatomy of Wonder* (1976) Neil Barron credits him with 'giving the lost race novel its form', an opinion shared by many. Rudyard Kipling, Haggard's close friend, wrote that Haggard's *Nada the Lily* (1892) had been the inspiration for *The Jungle Book* (1894). In *Edgar Rice Burroughs: Master of Adventure* (1965) Richard Lupoff traces Haggard's powerful influence on Burroughs.

At a more localized level, Haggard was a major influence on the development of Howard's love for fantasy literature and art. Howard began collecting Haggard books as a child and now has a significant collection of first editions – a cornerstone of his library. One of our daughters, Erica, is named after the Haggard character Eric Brighteyes.

The Haggard illustration project (initially suggested by Jane, seizing upon Howard's literary love) is envisioned to be a series of major paintings commissioned from today's leading illustrators. We hope to capture the spirit of Haggard's greatest works in what could be a lasting contribution to the field. For each of the most significant or memorable of Haggard's fantasy novels we are commissioning an illustration from an outstanding artist whose style is best matched to the spirit of that novel. The overall project is contemplated to include fifteen to twenty books and span several years.

So far, three paintings have been delivered – *King Solomon's Mines* by Don Maitz, *Pearl-Maiden* by Gary Ruddell (for the 1903 novel) and *The World's Desire* by Jeff Jones (for the 1890 novel which Haggard co-authored with Andrew Lang). Three further paintings are under way – Richard Bober is interpreting *Cleopatra* (1889), Steve Hickman will create the painting for *Nada the Lily*, and Bob Eggleton has committed to illustrating *The Ancient Allan* (1920).

For a while, Howard became obsessed by the choice of an artist for what is possibly Haggard's most important work, *She*. We were both thrilled when Michael Whelan, after a visit to our house with his family, agreed to the project. While no fixed date has been set for completing the painting, we await it with great anticipation since Michael is sure to create a memorable work.

The Haggard paintings will be hung in a room built especially for the project. This room, measuring 18ft x 27ft (5.5m x 8m), will be part of the new extension we are adding to the house. It has already acquired the obvious name of the Haggard Room, and will have decor appropriate to Haggard's time: coffered ceilings, oriental rugs

Above, from left to right
Hannes Bok: ***Gizzlesteen, Grimalkin***
and ***The Flying Grozzle*** (our titles)
with photo halftone (right) of the
complete work as it was seen at a 1948
book festival
Oil on masonite.
Full mural about 5ft x 6ft (1.5m x 1.8m).
*Reproduced by kind permission of
the artist.*

on the floors, wainscoting on the walls beneath appropriately patterned wallpaper, and 'Gothically' figural furniture from or in the style of the Victorian Renaissance Revival. We hope that the combined effect of room, paintings and furnishings will have the monumental impact deserved by Haggard's place in fantasy fiction.

Other rooms in the extension will gain their own monickers as artworks find their place. We have long been searching for a room to hold the many exotic weapons, masks and tribal materials that we have gathered over the years; our new guest bedroom – to be called The Veldt – would seem to be an appropriate home, and it would also provide display space for Boris's *The Nubians* (not shown) and the six paintings making up Barclay Shaw's *Tarzan* series (not shown). We expect friends will be as cheered by the sights – and as comfortable – there as in our existing guest room.

The addition will also provide welcome new wall space for another recent project: the recreation of a mural painted by Hannes Bok (real name Wayne Woodard, 1914–1964). The original was exhibited at the Associated Fantasy Publishers display at a book festival held at the Museum of Science and Industry, New York, in November 1948. The mural must have caused a stir when first shown there; certainly it was memorable.

According to Erle Korshak, owner of Shasta Press and thus one of the publishers whose books were on display at the booth, it 'regrettably... did not remain intact'. Shortly after its exhibit at the trade show the mural was destroyed; we have recently been told by Gnome Press publisher Martin Greenberg that this was done probably by Bok himself, sawing it up for what he may have

considered more 'saleable' pieces – i.e., those sections featuring the 'creatures', and in manageable dimensions.

It was from Gerry de la Ree's collection that we acquired, in September 1992, *Gizzlesteen*, as Gerry always called that portion of the mural which he owned. He mentioned in passing that it was 'part of a larger painting' but never provided any details. It was not until 1993, when casually reading Lloyd Arthur Eshbach's book of memoirs *Over My Shoulder* (1983), that Howard accidentally came upon a photograph of the mural as it had appeared at the fair. 'Eureka!' he exclaimed, then started wondering… whatever became of the rest of the mural?

A partial solution to the puzzle arrived in March 1997, when – out of the blue – a book dealer who had seen *Gizzlesteen* offered us Part Two, which we promptly decided to christen *Grimalkin*. It was truly incredible that a second part of the painting had survived and even more amazing that it had turned up in the hands of a dealer who knew to call us. To add to the extraordinaries, we were told there was a third piece to be had – if and when the owner decided to sell it. That did not occur until December 1998, when *The Flying Grozzle* joined his brethren.

It would be tempting to think that further pieces of the puzzle have survived, but we don't believe that to be the case. It would be typical of Bok's thinking that he would decide the rest of the mural was immaterial to collectors or other potential purchasers – 'nothing exciting there', just stacks of books and the bottom portion of the seated figures.

But wouldn't it be great to see what visual impact this work might have had when intact? It is with this in mind that we are proceeding with a project to recreate the missing portions; not with the intent of inventing or matching the colours Bok used, but rather to portray the figural elements and the proportions. The completed mural should be a work of size estimated at 5ft x 6ft (1.5m x 1.8m), with the surviving pieces positioned as shown in the photograph (see page 103) and the missing elements reproduced *en grisaille* so as not to deceive or confuse the viewer.

We'll need a big wall for that one. Coming soon!

AFTERWORD

Don Maitz

The collection that encompasses the interests and efforts of Jane and Howard Frank is much more than a body of work drawn from an imaginative genre. It is a sweeping documentation of an artform and a reflection of the personal tastes of the collectors. The collected works are also a celebration, a gathering of talent with a selective guest list.

The couple who host this creative ensemble are special in their own right. There are people who buy original art. There are those who are inspired to collect many individual works. There are rare collectors who have amassed a wide selection of beautiful and important paintings and sculptures.

Then there are the Franks.

They have spent years of enthusiastic world travel pursuing works of fantastic art. Wherever there is a major display of artwork that pushes the limits of the imagination, Jane and Howard are there. Not only do they show up but they interact, they participate. They attend openings of shows and convention art exhibits. They're in the audience at artists' slide presentations. They constantly share their enthusiasm and ideas over meals with artists. They listen. They speak on panels about collecting art where they openly discuss what to look for, how to preserve works and, importantly, how to be responsible to the artist whose work you possess. This openness and sharing of knowledge is part of what makes the Franks special – they care about the artists and the works they create. They have supported artists in crisis. They have donated time and money to art organizations whose treasuries were in desperate need. Jane's Worlds of Wonder catalogues, videos and website have provided income and promotional benefits for a cast of artists worldwide. The Franks have supported artists who wish to create special inspired works that otherwise might not be completed; for example, through their own special Haggard project they are watching their best-loved stories coming to life through the talents of artists they feel lend particular insight to the written work. These unique interactions between collector and artist are what make the Frank Collection stand alone.

Jane and Howard Frank have traditionally hosted a party at their home to view the collection whenever there is a gathering of artists nearby. The World Science Fiction Convention held in Baltimore during August 1998 presented just such an opportunity. Jane and Howard laid on a bus to bring all their invited guests. Unable to attend the party and never having seen the Franks' home and art collection, my wife Janny and I were invited to a special viewing hosted by Howard. What a treat. With a twinkle in his eye, he led us on an expedition around acquisitions that were a wonder to behold. I saw many fondly remembered works from various showings I had attended over the years. Around every corner were originals by artists I knew personally. I was struck by the feeling you get when you go to a party at a stranger's house and see old and new friends

Lisa Snellings: ***Crowded After
Hours***, kinetic sculpture, personal work,
1995.
Mahogany, resin and mixed media.
48in x 36in x 15in (122cm x 91cm x
38cm).
Reproduced by kind permission of the artist.

This is one of the sculptures that make
up Snellings's fantasy circus and
sideshow: a twelve-station mahogany
and mixed media Ferris wheel. Other
works are *This Wheel Goes 'Round, Too*
(1996), a kinetic and musical fantasy
animal carousel, and a 3ft x 6ft x 3ft
(91cm x 183cm x 91cm) roller-coaster,
Short Trip to October (1997). All three
works were exhibited together for the
first time at the 1998 World Science
Fiction Convention.

together in hitherto unknown (and in this instance spectacular!)
surroundings. I was introduced to original work I'd never seen by
artists I know quite well and also to original work I knew quite well
from books and reproductions by artists I had never met. And then
there were beautiful works by artists I had yet to discover.
This served as a testimony to me as to the depths of the Franks'
knowledge and their determination to represent the entire scope of
this field. And there were not just flat artworks here: there was a
wide range of sculptures to walk around and interact with in a way
that mere photographs cannot offer.

An important aspect of the collective array is that, in most cases,
there is not just one work per artist but a representative selection to
demonstrate properly the artist's ability. The Frank home is like a
neverending party where the talented and famous guests are
hanging from the walls and on pedestals, inviting you, the visitor, to
come over and spend some time with them.

The hanging of original art plays a crucial part in its effect on
the viewer. Where to place work that will show it to best advantage
is a challenge. Howard has developed a clever arrangement that
presents his art and book collections simultaneously; wooden panels
that slide from side to side on front recessed bookcases, so that
both wall space for the art and access to his impressive library are
offered at the same time. Artworks are displayed in rooms designed
specially to suit them, transitional works appear on stairways,

and dramatic works are given carefully tailored display space and lighting.

As I stumbled from room to room – quite literally stumbled, because I was watching the walls instead of where I was going – there was a definite sense that the tastes and personality of the collectors had been given room to play. Whose work greets the delivery man at the door? What work pulls at you from the end of the hall? What work spooks you out when you close or open a door? What work looks over you when you are eating? Whose work is that hanging in the bathroom? These particular decisions involve living with art: they do not confront museum and gallery curators.

A city in my home state still hosts the lifetime collection of a husband and wife who were renowned art connoisseurs. They travelled the world extensively and purchased many classical works of art. As their collection grew, a bigger facility was needed to accommodate the works, and this became the John and Mabel Ringling Museum of Art, the state art museum of Florida. I mention this because the same spirit, dedication and love of art that inspired the famous circus magnate and his wife are evident in Jane and Howard Frank. The book you hold in your hands is a shining example of the couple's taste and enthusiasm, put into a form that can be shared by a worldwide audience.

Paul Youll: **Excession**, cover for the novel (Bantam/Spectra, hardback) by Iain M. Banks, 1998.
Oils.
16in x 36in (41cm x 91cm).
Reproduced by kind permission of the artist.

We bought *Excession* – our first and so far only Paul Youll painting – at the 1997 World Fantasy Convention in London. We knew it wasn't going to be easy; he and his twin brother, Steve, are infamous for not wanting to part with their art. Then he saw his brother sell us a painting at the convention art show; when Howard turned to Paul and said, 'See how easy it is?', Paul changed his mind on the spot!

APPENDIX

STEWARDSHIP

Jane once heard a major collector offer four main reasons for collecting:

- to save the art or the artist from oblivion,
- to rescue or salvage art that might otherwise not survive,
- to save it for posterity, and
- to enable the art to 'escape the indignity of being in someone else's collection'!

Whether one's motives are 'pure' or driven solely by acquisitiveness, the overall message being communicated by these stated reasons is that collectors have a responsibility towards the art they acquire. There is no sense in sparing art the `indignity' of belonging to others if during its tenure with you it is left to languish, untended, leaning against a damp wall next to the oil furnace in your basement or sandwiched between two sheets of cardboard cut from a moving carton. Rough treatment, indifference and ignorance will result in oblivion for the piece of artwork, however noble your motives.

When visitors to an art museum look at a Renaissance drawing on paper they are witnessing a miracle of preservation that few private collectors can comprehend, let alone afford. Collectors who limit their holdings to works from the twentieth century have less need for miracles, but still they require an understanding of the steps they should take to ensure that these works — like those created in the Renaissance — will survive for five hundred years.

Part of some modern collectors' complacency is justified: paintings in oils on canvas have been proven to last lifetimes. Works in bronze are rather sturdy. And framers today are knowledgeable about acid-free papers and water-soluble glues. Nevertheless, like book collectors, art collectors are at the mercy of the materials of manufacture, and — in the case of illustration art — of the historical attitudes and practices which have influenced the degree to which the art has been able to survive.

By and large today's techniques tend to be superior to those employed by the artists of earlier decades. Nevertheless, illustration as a whole continues to be more facilely produced by artists, more cavalierly handled by clients, and less tenderly treated by collectors than so-called Fine Art. Severe time constraints and deadlines may force artists to take shortcuts in the production of the art — base surfaces are not always prepared properly; drying times are overlooked; protective coatings are forgotten; and the incompatibilities of certain media are ignored. Also, the needs of the commercial art industry mitigate against perfect survival. The art often must pass among various handlers and processors while it is being scanned,

photographed, reproed, proofed… And, after all of this, collectors can be at fault as well in that they often remain ignorant of the sometimes simple ways they could be helping to ensure the preservation of the art.

It is frequently the case that vintage (1950s–1960s) and classic (1930s–1940s) examples of illustration art require special care and handling. For example, we invariably reframe such art because the materials available today are superior to those used even twenty to thirty years ago. We also work hard to make sure that the matting and the frame complement the painting. The proper frame on a merely good painting can create an effect of greatness; conversely, a truly great painting, badly framed, can offer a disappointing overall image.

Collectors must be aware of the damage that can be done by natural and artificial agents such as sunlight, heat, air, moisture, plastic, glue and acidic papers. We take care to clean and restore any painting that would gain materially by that effort. We subscribe to framers' magazines and art magazines, and maintain a library of books on subjects like curation and preservation techniques. We're often amazed at how a simple cleaning and reframing of a classic painting can bring alive apparently dull colours and lifeless images, and wonder why previous owners haven't done the same – if for no other reason than to increase the worth of the object when they sold it.

Sunlight, both direct and indirect, and fluorescent lighting are rich in ultraviolet rays and are therefore harmful to paper as well as to certain inks and colours. Artwork and collectibles should be displayed in rooms without windows, if possible, or at worst subjected to only weak daylight, and ought to be illuminated with incandescent (rather than fluorescent) lighting, which is relatively harmless.

Because the standard manufacturing processes used to produce twentieth-century paper is acidic, the preservation of paper products presents a special challenge. Works on paper should be stored in acid-free cases and cartons, or between layers of acid-free tissue paper. Document repair tape, backing boards and every other item that comes into contact with paper items should be acid-free. Even a small amount of unprocessed wood pulp in the mounting or backing boards may contain acids which 'burn' paper, causing it to turn brown or brittle or even to disintegrate when removed from the frame or protective sleeve. Also, not all papers described as acid-free actually are. Rag conservation board with a pH factor between 7.5 and 8.3 is recommended for matting and backings for works on paper. Even the hinges suspending a limited-edition print should be acid-free.

Ultraviolet blocking via glass or plexiglass helps, and neither should ever be in direct contact with the surface of the framed object. Note that plexiglass should not be used with chalks/pastels or charcoal drawings because plastic attracts static electricity that can cause the chalk to migrate from the paper to the plastic.

Paintings in oil and some acrylics do not require framing under glass, although it may be done to protect the surface and to keep the work 'clean' in a polluted atmosphere. In this context wood-burning

fireplaces are particularly bad culprits and should be banned from homes with valuable items – quite apart from the danger of fire, the soot and airborne particles destroy the surfaces of paintings and other artworks. (We had our fireplace converted to burn gas.) Humidifiers help, as do strict temperature controls.

We also keep an eye on a different kind of preservation: security. Alarm systems and other advanced security measures are a fact of life for serious collectors. We do not leave our home untended for periods of time, even when we travel. Our house is saturated and surrounded by all sorts of security alarms to protect against vandals and would-be art liberators.

We do not use electric floor heaters or halogen lamps, or keep pets which might gain access to art on tables and pedestals. We taught our children early on to respect the possessions of others, but we do not extend the same trust to children in general: young visitors to our house are always supervised.

The thoughtful collector displays artworks so as to make their subtleties easier to grasp and so that their best points can be seen to greatest advantage. Over the last decade, Jane has been active in her efforts to help other collectors become more educated. In 1991 she started Worlds of Wonder (WoW), an enterprise specializing in the sale of original science-fiction and fantasy illustration, and she is constantly working to match potential collectors with the more than forty illustrators she represents. She established WoW when, after touring our house, many visitors expressed interest in acquiring some of our art for themselves. Since we don't sell works from our collection, Jane soon became a matchmaker, putting artists and potential collectors together. After a few simple introductions like this she found that she was beginning to spend nearly all her time at the enterprise, and over the last few years she has sold over two hundred pieces of art annually. She is constantly helping would-be buyers select art, and in the process spends endless hours giving tips on framing, preservation and the general care and treatment of paintings. (Worlds of Wonder has a website at www.wow-art.com.)

If price were no object and space considerations not a real factor, a majority of collectors would still resist living in the Metropolitan Museum of Art, even if a small kitchen and bathroom were to be attached to the main entry. That's probably because living with artworks is different from viewing artworks in a public place. In the final analysis, you must judge how to balance the need to enjoy your collection with the need to preserve it. These two needs are not necessarily mutually incompatible, but quite often the showing off of your collection requires you to expend a bit of thought lest the pleasure you gain in seeing the beauty of the artworks in your possession is being bought at the expense of the artworks themselves. It may seem paradoxical, but just because you own those artworks does not mean they are yours.

INDEX OF ARTISTS AND WORKS

Works are listed in *bold*.